LEGENDARY

OF

OCEANSIDE

NEW YORK

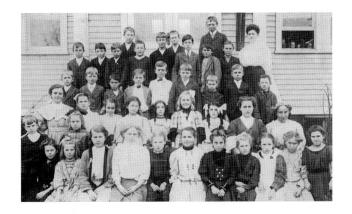

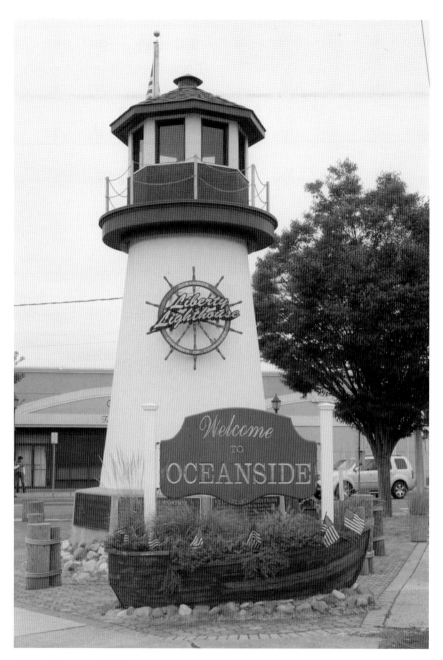

Oceanside's Liberty Lighthouse
Liberty Lighthouse, located on the Oceanside Triangle, is a beacon welcoming people to Oceanside. The Triangle is a historic site. It was stop No. 102 for the trolley in the early 1900s and was designated as a memorial to veterans in later years. Kathy Towers created the renovation design, and legislators Jeff Toback and Michael Zapson, along with County Executive Tom Suozzi, secured the funding. (Courtesy of Wendy Woods.)

Page 1: Oceanside Schoolchildren
These children are pictured with their teacher in the early 1900s. (Courtesy of Marian Wagner.)

LEGENDARY LOCALS

OF

OCEANSIDE
NEW YORK

RICHARD WOODS

LEGENDARY
LOCALS

Legendary Locals is an imprint of Arcadia Publishing
Charleston, South Carolina

Printed in the United States of America

Library of Congress Control Number: 2012946316

For all general information, please contact Arcadia Publishing:
Telephone 843-853-2070
Fax 843-853-0044
E-mail sales@arcadiapublishing.com
For customer service and orders:
Toll-Free 1-888-313-2665

Visit us on the Internet at www.arcadiapublishing.com

Dedication
To Debbie Pearsall, who embodied an inimitable spirit, energy, and passion for life

On the Cover: From left to Right:
(TOP ROW) Diane Farr, actress and author (Courtesy of LauraKate Jones; see page 102); Gilda Gray, Ziegfeld Follies dancer (Courtesy of Lawrence Herny Archives; see page 104); David Paymer, actor (Courtesy of Larissa Underwood; see page 98); Dennis Leonard, pitcher for Kansas City Royals (Courtesy of Frank Januszewski; see page 86); Rufus Smith, banker and realtor (Courtesy of the Picture Collection, New York Public Library; see page 16).
(MIDDLE ROW) Arthur Heyman, Duke and New York Knicks basketball (Courtesy of Michael Limmer; see page 84); Ruth Lewis, high school teacher and coach (Courtesy of Sean Keenan; see page 26); Julian Arechaga, Marine Corps sergeant (Courtesy of Sheyla Randazzo; see page 78); Penny Ellis, National Educator of the Year (Courtesy of Penny Ellis; see page 33); Robert Iger, Disney CEO (Courtesy of Disney; see page 43).
(BOTTOM ROW) Ronald Winchester, Marine first lieutenant (Courtesy of Marianna Winchester; see page 79); Townsend Southard, farmer and community leader (Courtesy of Andy Southard Jr.; see page 13); Joseph McDonald, civil rights activist and Freedom Rider (Courtesy of US government; see pages 38–39); Edyth DeBaun, camp proprietor and civic leader (Courtesy of the DeBaun family; see page 21); Jay Fiedler, National Football League (NFL) quarterback (Courtesy of Frank Luisi; see page 87).

CONTENTS

ACKNOWLEDGMENTS

Many people invited me into their homes and treated me like family. They loaned me their heirlooms and precious photographs without reservation. I graciously and sincerely thank them. Some of the same names associated with the development of the community aided in the development of this book. Edyth DeBaun and Pamela and Kenneth Lucas spent time reminiscing and telling old stories of Oceanside, as did Jack and Ellen Lucas and Craig DeBaun. Dorothy and Linda Hendrickson gave me tremendous help (and good blueberry pie). They are two of the nicest people to have lived in Oceanside. MaryJane and Robert Baumann welcomed me and spent long hours going through pictures and sharing memories. Keith Pearsall and Michael Orzano have a sense of local history matched by very few. Maria Heller, "Ms. Do-It-All," was a wealth of information and a source of numerous photographs. Bill Lynch was always willing to run from here to there to help in any way possible. Andy Southard Jr. has not lived in Oceanside for a while, but it is still dear to his heart. He can talk forever about sites and memories and he shared many photographs. Howie Levy was a great point man and is a Hall-of-Fame "Sailor" if there ever was one. He helped connect me with some key people in this book. Marian Wagner was a tremendous help, filling me in on the Ramsden family, supplying pictures, and generating ideas. Joan Ivarson is an expert on "the Neck" of Oceanside down by Mott Street, and she graciously helped me with information on the Bedell family. Barbara Guzowski, Geri Solomon, and the librarians at Hofstra Long Island Studies were generous with their time and assistance. Doris Chwatsky was the curator of historical Oceanside documents and artifacts that she recently donated to Hofstra Library. Many were used for this book. Thank you, Doris.

Other people have been inspirational over the years. They love local history and gave me energy for this project. Michael Limmer loves to chat about graduates from Oceanside High School and what they are doing today. Betsy Transom's enthusiasm for local history gives us all inspiration. Seth Blau, a new school board member, has a passion for local history that guarantees the work will continue. Frank Januszewski is another great man who can talk all day about "old" Oceanside.

My wife, Wendy, lost her husband and my daughters, Jaime, Justine, and Julia, lost their father to a project whose hours kept adding up. I thank them for their patience, sacrifice, and support.

The following people helped me also in various ways and I am grateful for all of them: Suzanne Dwyer, Tom DiDominica, Dr. Herb Brown, Joseph McDonald, Carol Croce, Frank Nappi, Rabbi Uri Goren, Evelyn Rothschild, Donna Lamonica, David Portnoy, Harvey Gluck, Robert Moyer, Priscilla Merryman, Sheyla Randazzo, Peggy Hynes, Jill Krol, Bonnie Januszewski, Maryanne Marino, Amy Gardner, Irene DeSantis, Shari Goldman Florio, Sandy Bettes, Christine Clancy, Bill Vogelsberg, Conor Pasetti, Gail Carlin, Steve Baumann, Ralph Marion Jr., Richie Shor, Morty Shor, Tyler Brownwell, Stephanie Fullam, Willard Eldred, Barbara McGuinness, Joel from the Veterans of Foreign Wars (VFW) post, Nancy Lopez, Wayne Vurture, Tiffany Frary, Ed Fried, Virginia Cser, Erin Vosgien, Lisa Ross, Kimberly Waldman, Chris Peterson, Alice Nowak, Bill Handwerker, Tim Olsen, Michael Boss, Stephanie Voltz, Judy Fishkind, Barbara Messier, John Robbins, and Donna Kraus.

INTRODUCTION

The heart of Oceanside is its people. It is not a business, sports arena, or tourist attraction that defines the community. Its strength lies in its inhabitants. In this book, I recognize Oceanside citizens. It is an impossible task to fit all of those who have made this community great within a 128-page book. I ask the reader to please understand that these notable people represent all of us. The book is not a comprehensive tome but rather a light read. It will provide insight, enjoyment, and bragging rights. It is more of a highlight film than a documentary. Maybe it will spark an interest in local history for some.

My aim was to thank and praise civic and charitable leaders while recognizing prominent natives. These leaders exhaust themselves to create a livable, caring environment. It is one that is conducive enough to coax generation after generation to remain here to raise their children. This environment created by our "unelected leaders" supersedes the green flies at Oceanside Pool, water in our basements, Mount Landfill, or traffic jams on Waukena Avenue. We like it here.

Oceanside has an unofficial, coordinated network of caring citizens who pop up for every charitable event and try to improve our community. It has probably been this way since our first inhabitants arrived.

Our origin is not so different from most of Long Island. Oceanside's Native Americans were the Rockaways. They were attracted to the wetlands, bays, and fertile soil that enabled them fish and farm. They were followed by the Dutch who came here to trade and then by the English.

It can be assumed that white settlers farmed Oceanside in the 1600s, but records are sketchy. The Church of England and its government were intertwined. The church began to assume properties in our area in the 1600s. One large parcel of land from Merrick Road to Middle Bay was named the Parsonage Farm. Early records from 1682 say, "A glebe of 100 acres near the South Bay was voted by the Town of Hempstead to the use of minister, Jeremiah Hobart." This is probably the first legitimate evidence about the settlement of the area that is now Oceanside. Parsonage Creek forms a hook to its south, and Christian minister Hobart received the property. This possibly generated Oceanside's first name, Christian Hook.

Our first documented "legends" were the Pettits. Records show that James S. Pettit bought the Parsonage Farm in 1826. His family's farmhouse was built in 1724, so they must have lived in Christian Hook earlier. From wedding and baptismal records, some early-1700s Christian Hook names were Carman, Mott, Eldred, Story, Cornell, Bedell, and Hicks.

Christian Hook had a schoolhouse during the Revolutionary War. Records show it was taken over by British soldiers. Our first individual legend may have been Increase Pettit. He was part of a militia during the Revolution and helped to prevent the British from landing on Long Beach. One night, he risked life and limb to rescue a patriot swimming away from British boats. Another was Col. Daniel Bedell who, during the War of 1812, organized military regiments for home defense. After the war, he was designated a general.

Throughout the 1800s, the population grew from approximately 15 farm families to about 300 people. People lived rural lives, growing and selling crops, raising livestock, and digging oysters. They travelled by horse and wagon to Brooklyn to sell their wares. They attended the Presbyterian church and enjoyed socializing at each other's homes and at the occasional fair and festival.

Our Public School District No. 11 began in approximately 1833. Our "little red schoolhouse" was on the northwest corner of Foxhurst and Oceanside Roads. Tony "Poppy" Waring was the first teacher.

During the Civil War, Christian Hook had admirable soldiers with the names of Denton, Soper, Miller, Smith, Story, Jones, Pettit, Eldred, Murray, Anthony, Phillips, and Rhodes fighting for the Union. Around this period, our oyster business took off. Because of this boom, our name changed from Christian Hook to the more maritime Oceanville (1864). Oceanville Oysters were in demand in all the major New

York City restaurants. Alexander "A.A." Pearsall and William Mott were dominant in the business. The Ramsden family, Zachariah Story, and Joseph Brower were also chief oyster planters. Oyster houses by Oceanville waters would fill to capacity. Women would shuck oysters for 3¢ per hundred.

The 20th century rolled in, and so did our new trolley. A key stop was No. 102, known to Oceansiders as "the Triangle." Lorenzo Davison had his general store on the northeast corner of Foxhurst and Oceanside Roads, which housed our post office. We changed our name to Ocean Side in 1889 because another post office was using Oceanville. Our first fire department—Salamander Hook, Ladder and Bucket Co.—was created. Two Oceanside soldiers died in World War I. Blacksmiths like Warren Abrams and Alexander Rhodes still made horseshoes and bay implements. Farming and shell fishing remained our industries. Then, the population exploded.

In the Roaring Twenties, Oceanside grew from a population of 300 to 6,000. It was a manic decade. Realtors bought plots from farmers who cashed in. Oceanside was touted to outsiders as a desirable domicile near the city and the ocean. New residents brought faiths of Catholicism and Judaism, and there was growth of ethnic groups, including the Irish and Italians. The Baumanns came to town and entered every area of civic leadership. Suffragist Jeanne Marion Doane wrote speeches in south Oceanside while Gilda Gray shimmied up North. Fr. Robert Barrett built St. Anthony's underground church. Rufus Smith founded Oceanside National Bank, and rumrunners brought in booze. Vaudevillian Frank Tinney held Gatsby-like parties on Foxhurst Road, and Charles Beall gave kids llama rides at his zoo by Mott Street.

In the 1930s and 1940s, Oceanside survived the Depression and World War II with the glue that held us together throughout the 1900s: kind families, volunteer firemen, school personnel, religious leaders, and caring individuals. Hundreds of Oceanside men enlisted during World War II, with many never to return. When people had a little money, they visited the Roadside Rest for dining, dancing, and music. Legendary educator Walter Boardman ran our school district, modeling civility and charity.

During the 1950s through the 1970s, the population had another spurt. Our formerly rural hamlet became a full-fledged suburb. Murray Handwerker opened Nathan's, which became the popular hangout. Brave citizens fought during the Korean and Vietnam Wars. Southern Oceanside, once covered with wetlands, was now covered with houses. Oceanside Park and Pool were built.

The 1980s and 1990s saw the advent of Oceanside Middle School, the closing of Oceanside's Landfill, and the razing of School No. 1. The Barry and Florence Freidberg Jewish Community Center became a welcome addition. We mourned our citizens who perished during 9-11, and our men and women fought bravely in the Gulf, Iraq, and Afghanistan Wars. Superstorm Sandy, in the fall of 2012, bonded us together like never before, with neighbors helping each other in an impressive show of charity and altruism.

As we move forward in this millennium, we hope for peace and prosperity. We continue to work together to create the best community possible. Our formerly white, Anglo-Saxon, Presbyterian community is now white, Anglo-Saxon, Hispanic, Indian, Asian, and African American and practices many religions. Our future will be bright if our inhabitants are as active and generous as their ancestors. I look forward to seeing who will take over the reins from our leading citizens and who will be the next Oceansiders to move the world.

CHAPTER ONE

People Who Shaped the Community

The history of Oceanside can be told as the story of its families and citizens. They shaped the community and molded its identity. Some of the families identified in this chapter played a significant role in Oceanside's formation. They took it upon themselves to see Oceanside was headed in the correct direction. When there was a need, they sought to fulfill it. When politicians needed a push so that Oceanside would get its fair share, they pushed. When people needed assistance, they organized. No family better demonstrates leadership than the Baumann family. They were involved in improving every aspect necessary to make Oceanside a coordinated, functioning community.

While important citizens and families influenced Oceanside's growth, others were also hardworking contributors. "Newer" families have worked to sustain what the pioneers accomplished and improve it. They work as hard as their predecessors with the same inherent desire to help. The families mentioned in this chapter are not the only ones who cared enough to make Oceanside a better place. Street signs, school attendance registers, and newspaper archives all have family names like Dapolito, Davison, Story, Mott, Wood, Watts, Wright, Shapiro, Vandermosten, Abrams, Langdon, Cornell, Rhodes, and Combs—all of whom contributed to Oceanside's development.

The Pettit Family
The Pettits were Oceanside's first white settlers. Joshua and Mary Pettit farmed by Parsonage Creek in the 1700s. Their farmhouse was built in 1724. In 1826, James S. Pettit purchased the land outright from St. George's Church of Hempstead. It became known as Parsonage Farm, one of the largest farms on Long Island. A Pettit family gravesite (pictured) exists on Fortesque Avenue with the graves of Mary (1771–1849) and James Pettit (1757–1846). (Author's collection.)

Oscar Terrell
Terrell Avenue is aptly named. Oscar's father, Daniel, and others built Oceanside's first hard-surfaced road. At the time, renowned sculptor Philip Martiny and Teddy Roosevelt's uncle Robert were residents of Terrell Avenue. In 1889, when he was 14 years old, Oscar travelled to Brooklyn to sell the oysters, eels, and clams that his family cultivated. Oscar and his father were charter members of the First Methodist Church of Oceanside. (Courtesy of the Hendrickson family.)

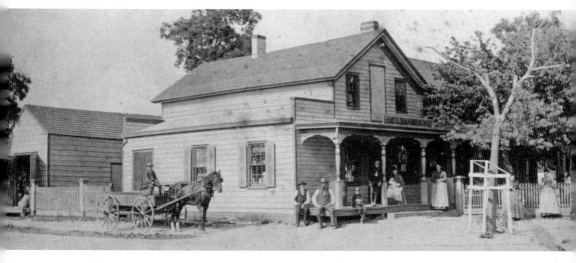

Lorenzo Davison

Lorenzo had a store on the northeast corner of Foxhurst and Oceanside Roads. He sold guns, flour, yarn, coal, and school supplies. He also had a poultry farm and blacksmith shop. His father George was a Christian Hook farmer back to the mid-1800s. Davison's Store was the great meeting place for men of the day to discuss politics and business. He was the first postmaster and fire dispatcher. (Courtesy of Baldwin Historical Society.)

The Soper Family

The Sopers were one of Oceanside's earliest families, going back to the early 1800s. They were farmers; their farmhouse on Oceanside Road is pictured. They owned land on which today lies the Oceanside Jewish Community Center. They also had land off Foxhurst Road by School No. 3 that was used for sporting events. During the late 1800s, the Sopers were the most prominent Oceanside family to convert to Mormonism. Some of the family hitched their wagons and traveled to Utah. (Courtesy of Jaime Woods.)

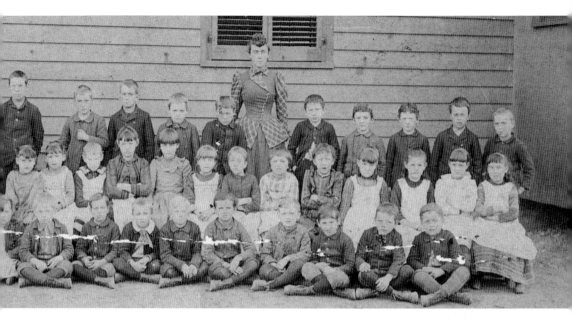

The Ramsden Family

Thomas Titus Ramsden was the patriarch of the Oceanside Ramsdens. He married Emily Wright, who was born in Oceanside (Christian Hook) in 1844. Emily's father was James Wright. The northwest corner of Oceanside and Foxhurst Roads was once nicknamed "Jim Wright's Corner." It was the site of one of Oceanside's first schoolhouses. Thomas and Emily originally lived where South Nassau Communities Hospital exists today. They later moved down Oceanside Road across from the Presbyterian church. There with nothing behind the house but eight acres of beautiful farmland, all the way to Long Beach Road. Thomas Titus was the first treasurer of the Oceanside Fire Department and maintained his own oyster business. Emily and Thomas had nine children. They all lived in Oceanside throughout their lives. Son Ernest owned Ramsden Sanitation Company, which predated the Oceanside Sanitation Department. Daughter Melissa, also known as "Bunny," married Gustave Brunger and was intricately involved in the Presbyterian church. She cared for the children of many pastors, taught Sunday school, prepared communion services, and started the first quilting club, known as the Bunny Circle. Bunny's brother Wright was an inspector for the department of public works. Wright's sons George and Thomas were outstanding Oceanside High School athletes in football and basketball. George became a professional golfer. Thomas was warden of the Nassau County Jail, and he was the last Ramsden to be born, live, and die in Oceanside. Thomas's wife, Beatrice, was Walter Boardman's personal secretary, a deacon of the Presbyterian church, and president of the Kiwanettes. Thomas was a member of the Kiwanis Club, a Republican committeeman, and a commissioner of Oceanside Fire Department. The Ramsdens are well represented in the 1890 picture, which shows Oceanside's three-room schoolhouse on the site where Schoolhouse Green now exists. Ada Hill is the teacher. Ada married Wright Ramsden. Also in the picture are Wallace Titus Ramsden (third row, fourth from left) and Ernest Ramsden (first row, third from left). The Ramsdens played key roles as educators, businessmen, laborers, and volunteer firemen in many facets of Oceanside. The family also owned a boardinghouse named Maple View on Long Beach Road. (Courtesy of Marian Wagner.)

Andy Southard Sr.

Andy, pictured at left, was a civic leader from a family that helped create the Oceanside residents know today. His father, Townsend F. Southard, donated a parcel of land to build the First Presbyterian Church. Within the church is a plaque honoring him. Andy was a pivotal player in the community during the 20th century. He was the first president of the Kiwanis Club and school board president. Andy was there to help raise the first cross at St. Anthony's Church, was secretary and treasurer of the Oceanside Fire Department, and was instrumental in the construction of sewers in Oceanside. His wife, Mabel, seen helping the sailor on the boat, worked for the American Red Cross while Andy was the head of the Civil Defense Fund during the 1940s. As a kid, Andy had a job feeding the elephants at Charles Beall's Zoo by Mott Street. (Both, courtesy of Andy Southard Jr.)

Charles and Dorothy Bedell

The name Bedell has been present in America since the *Mayflower* docked. It has been in Oceanside since the earliest days. Oceanside's Capt. Daniel Bedell rounded up military regiments to fight the British during the War of 1812 and was designated a general after the war. Bedell's Boatyard is a familiar sight in south Oceanside. However, the most prominent Bedells in Oceanside are descendants of Dorothy (Anderson) and Charles Bedell. Dorothy's family goes back to the 1800s. Her father, Linus, was a founding member of South Side Hose Company No. 2. Dorothy, Charles, their 13 children, grandchildren, and great-grandchildren populated Oceanside, participating in its organizations and activities for the last 100 years. The Bedells have worked in local transportation, hospitals, Oceanside School District, and for the Town of Hempstead. Their greatest benevolent service is via the Oceanside Fire Department. All nine of Dorothy and Charles's sons served as volunteer firemen. Ed and Richard were Oceanside Fire Department chiefs. Charles and Gary were captains. Daughter Joan (Bedell) Ivarson still lives on Mott Street. According to Joan, the area surrounding Mott Street in the early 1900s was nothing but wetlands ripe for spearing eels and digging clams. Blackberries and asparagus grew wild. The Anderson, Tredwell, Denis, Abrams, and Pratt families all took root there. A team named the Mudcats played baseball near where Wright's Field is today. Joan's father worked in the monkey house at nearby Beall's Zoo. There was a hotel, which ran booze during Prohibition, and Joan's grandfather operated a small store, selling cigarettes, candy, and soda. The store building exists today on their property. Joan continues the Bedell tradition of service. She is deeply involved in AMT Children of Hope. It is an organization that provides safe havens for abandoned children before they are legally adopted and provides dignified burials for abandoned, deceased babies. The Bedells have been an integral part of Oceanside for a long time and continue to be today. (Courtesy of Joan Ivarson.)

The Chwatsky Family
Morris and Hyman Chwatsky sold newspapers and dry goods to the community in the early 1920s. In 1927, they opened up the General Merchandise Store at Long Beach Road and Davison Avenue. Morris and Hyman peddled on the road while Bluma, Morris's wife, minded the store. The Chwatskys helped facilitate the beginning of the local Jewish community. Bluma worried, recognizing that some of their early customers were Ku Klux Klan members, but Morris believed that once people got to know them, they would be accepted. Their store grew over 70 years to become Oceanside's favorite, one that employed over 100 people. Chwatsky's store could clothe people from cradle to grave. Bluma, pictured above (far right) with Doris Chwatsky (left) and Minnette Gluck, worked into her 90s, becoming the town's unofficial Yiddish mother. Chwatsky's was still successful with the advent of megastores and malls but eventually closed its doors in 1996. Pictured is the dedication of the Memorial Triangle to World War II veteran Milton Chwatsky. Those standing with the sign are, from left to right, Michael Scarlata, Richard Guardino, Robert Towers, Howard, Joseph, Doris, and David Chwatsky. (Both, courtesy of Maria Heller.)

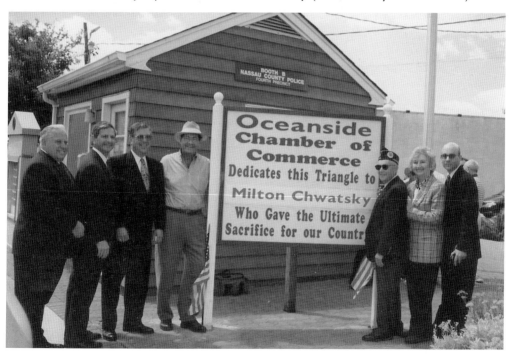

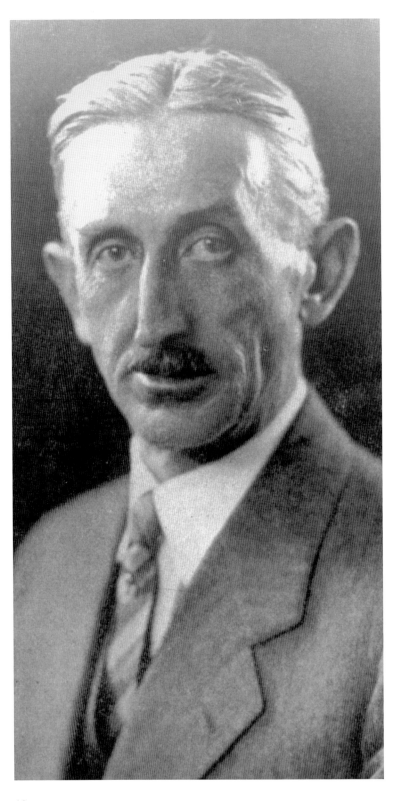

Rufus Smith

Rufus Smith grew up on his family's dairy farm. His mother was Sally Davison, born in Christian Hook in 1854. Rufus got a degree in law from New York University, but his career was real estate. He was one of Oceanside's most admirable civic leaders of the early 20th century. He was the chairman of the first board of fire commissioners and a member of the Kiwanis Club, the Republican Party, and the board of trade. He was also a trustee of the First Presbyterian Church for over 30 years. In 1923, he established the Oceanside National Bank and became its first president. Rufus virtually kept Oceanside solvent after the Great Depression. Knowing he might never be paid back, Rufus awarded loans. In 1948, after he died, his grandson Ernest Vandeweghe cleaned out his bank desk and found IOUs totaling over a million dollars. (Courtesy of the Queensborough Public Library, Long Island Division.)

The Baumann Family

In 1918, Harry and Emma Baumann bought a farm on Brower Avenue. At the time, Brower Avenue was lined with large, beautiful trees with trolley tracks running through. Around Brower Avenue were also the farms of the Peace, Burtis, Soper, Southard, and Gullick families. The Baumanns lived with Emma's parents, Maximillian and Anna Koehler, and theirs was the typical farmhouse of its time. Water was drawn from a well, a wood/coal stove heated the downstairs, and a galvanized tub was used for baths. Harry "Pop" Baumann was a man with a quick wit, wisdom, patience, and communication skills. He became the unofficial mayor of Oceanside. He was the force behind Oceanside's first sanitation department and helped organize the first board of trade. Emma was a Parent-Teacher Association (PTA) president and, with her sister-in-law Katherine Baumann, created the school hot-lunch program. She also worked with Christian Binner to establish Oceanside's first library and was an active member of the Ladies Auxiliary at South Nassau Communities Hospital. Harry and Emma's four sons and two daughters were known as the "Baumann Six." Bob was a Marine who played semiprofessional football. He started Little League baseball and was a president of the Kiwanis Club. With his wife, Rosalyn, he founded Baumann's Kiddie Klub and Nursery School, which delighted children for decades. His athletic talent and devotion to the community led him to be elected to Oceanside High School's Circle of Pride in 2009. Bob also founded Camp Baumann Bus Company with his brother Dick. Dick, an Army veteran, was a fire chief and rescue squad volunteer. He opened his own bus company, which still exists today. Howie, with his brother-in-law John Vandermosten and Fred Thomforde, was instrumental in the formation and development of the Oceanside Recreation Department. Howie was an outstanding coach. He coached the Nassau Collegiate Center, a two-year college set up during the Depression, to an undefeated season in 1935. Howie was a sanitation commissioner and was instrumental in developing one of Long Island's first recycling programs. He also helped start up Oceanside Stallions Football. Bill, a Marine veteran, was chief of the Oceanside Fire Department's Rescue Squad. He later moved to Vermont, where he became the commissioner of public safety for the state. Helen was president of the New York State PTA and encouraged the formation of Oceanside's PTA Council. She was also the vice president of the National PTA. Muriel was also actively involved in PTA. In 1969, she was the driving force for the development of the Oceanside Narcotics Council. Through the 20th century, the Baumann family's civic involvement helped move Oceanside forward. They set the foundation for much of what is Oceanside today. (Courtesy of MaryJane and Robert Baumann.)

The Pearsalls

The Clark Avenue house where Keith Pearsall lives sits on one of the oldest deeded properties in Oceanside. The Pearsall family was one of the earliest white families on Long Island. Lynbrook was previously named the Pearsalls. In Oceanside, Pearsalls have served as baymen and fishermen. Alexander Pearsall was an oysterman of note who donated the land to build St. Andrew's Church. Louis Pearsall, pictured, was a master union carpenter as was his son Arthur, who, after retirement, worked as a custodian for Oceanside schools. Walter Pearsall, Keith's father, was a science teacher and chairman at Oceanside High School for over 30 years. Keith volunteers for the school district's building and grounds committee, making sure the facilities function properly. Keith and his wife, Janet, raised two beautiful children—Deborah, to whom this book is dedicated, and Christopher, an Eagle Scout, gentleman, and Cornell graduate. (Courtesy of Keith Pearsall.)

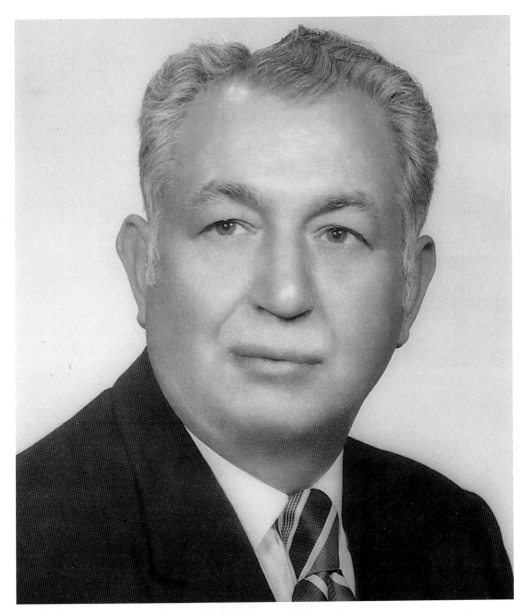

Pat Orzano

In the late 1800s, Italian immigrants Michael and Josephine Orzano raised cattle and made cheese on their farm at Lincoln and Perkins Avenues. The cheese was brought to Brooklyn by horse and wagon. Years later, the Orzanos built homes. Josephine's brother Dominick Milone got contracts to build St. Agnes, Mercy Hospital, and Molloy College. When the Orzanos built a laundry on Long Beach Road and the buyers lost their money in the stock market crash of 1928, they started Ocean Side Laundry. Son Pat (pictured), Oceanside High School Long Island wrestling champion in 1933, went on to serve on the board of South Nassau Communities Hospital. He helped found the Kiwanis Club, the Knights of Columbus, and the board of trade. The Orzanos and their descendants served Oceanside in education, medicine, auto service, business, firefighting, and philanthropic endeavors. They continue to do so today. (Courtesy of Dr. Michael Orzano.)

The Lucas Family

Jack Lucas and Ellen Mischo were recognizable Oceanside High School sweethearts. Jack was a three-sport athlete who won a county championship in basketball in 1947, while Ellen was a member of the cheering and twirling teams. They married and raised six boys, and their family has made an indelible mark on Oceanside. Jack became a master carpenter and imparted his skills to each of his sons. He was one of the first members of Oceanside's Knights of Columbus and served as a loan officer for the Oceanside Christopher Credit Union in its formative years. Jack advanced his prospects by venturing into Lucas Stone, later Lucas Lumber, with his sons in the 1980s. As the company expanded, it transformed into a multifaceted business. Currently, it is known as Contractor's Express, with a subdivision, Design Expressions. Jack Lucas Jr., vice president of the company, was recognized as Business Person of the Year in 1995. Additionally, the Lucas family built the Sands Shopping Center, a meticulously landscaped complex that allows Oceanside residents to shop at high-end stores. Carrying on Jack and Ellen's tradition of excellence in athletics, all six sons and six grandchildren were all-stars in football and/or lacrosse. The family remains compassionate and benevolent when a call for help rings out in Oceanside. They continue to contribute to charitable events that strengthen the community. In the picture are, from left to right, (standing) Steven, Jack Jr., Jim, Jack Sr., Kenneth, and Gary; (sitting) Ellen and Bob. (Courtesy of Kenneth Lucas.)

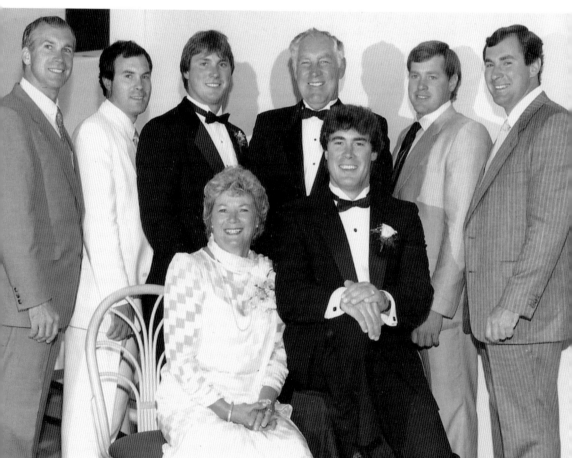

The DeBaun Family

In the late 1930s, Joseph DeBaun's exuberance for Oceanside High School manifested as a member of the cheerleading team. He wore a sailor's uniform at each game. So poignant was the sailor suit, the school adopted the nickname "Sailors," later to eventuate into Oceanside's mascot. Serendipity brought Joseph and Woodmere High School cheerleader Edyth Oppenheimer together at a basketball game. Later, this encounter was to become a love affair, not only with each other, but also with Oceanside and its community. Edyth and Joseph, with the encouragement of Edyth's father, Milton (affectionately known as Gramps), would commence a legacy by providing generations of children with memories at Camp DeBaun. "Uncle Joe" delighted campers as he greeted them each morning wearing a variety of costumes, and "Aunt Edyth" served as business administrator. The entire family worked at the camp, and those who were not family soon became part of the DeBaun family. Edyth and Joseph raised four children—Bruce, Craig, Priscilla, and Pamela—in the same spirit of service they exemplified. Delivering holiday baskets, visiting the homebound, and singing Christmas carols at nursing homes was a matter of course for the DeBaun kids. As time passed, Craig and Pamela remained in Oceanside to continue the work their parents birthed. Craig married Annette Sabella, and they both worked at the camp and in the community. Pamela wedded Kenneth Lucas, her Oceanside High School sweetheart, whose expertise in construction renovated and created new structures at the camp. Joe was a proud veteran of World War II, president of the Kiwanis Club, and a member of the Knights of Columbus. Edyth has remained a model of civic leadership whose philanthropic contributions could fill this book. Her humility belies her honors, which could fill another. She has been recognized as Mother of the Year and Businesswoman of the Year and was the first president of the Kiwanettes. A 36-year member of Hose Company No. 1, Craig has served as captain and fire commissioner. Annette is a past president of the Kiwanettes, and Pamela and Kenneth have richly supported the youth and athletics in Oceanside. A veritable deep and lasting love of Oceanside has encompassed the DeBauns' minds, hearts, and souls. The picture above shows, from left to right, Milton Oppenheimer, Pamela, Bruce, Edyth, Joseph, Craig, Annette, and Priscilla DeBaun. (Courtesy of Pamela DeBaun.)

The DiDominica Family

Thomas DiDominica created one of Oceanside's finest businesses. For 60 years, Dee's Nursery and Florist has provided people with knowledgeable advice, expert service, and exquisite plants. Tom's father (also named Tom) was a bank vice president and Oceanside School Board treasurer who offered his son support and encouragement. Sixteen-year-old Thomas started his business selling daffodils and lilacs at a stand on the corner of Lincoln and Atlantic Avenues. Many of his customers were people attending Mass at St. Anthony's Shrine Church. After graduating Oceanside High School in 1953, Tom attended Farmingdale College, studying horticulture and putting his lessons to good practice. Tom's high school sweetheart, Adele Dukes, graduated Sacred Heart Academy in 1955 and attended business school in New York City. They married in 1957. Their business gradually expanded to encompass four acres with a florist, greenhouse, garden center, and gift shop. Dee's is a family affair. Of their eight children, five work in the business. During the holidays, it is not unusual to see all eight working along with a few of the 25 grandchildren. The DiDominicas have an organic Christmas tree farm in Maine from which they harvest 5,000 trees each year. It serves as a model for other tree farmers. In 2007, the National Christmas Tree Growers Association hosted its convention there. Holidays are fun times at Dee's. During Halloween, kids pitter-patter through the scary haunted house. Christmas season brings out beautiful decorations, hot apple cider, a petting zoo, and "reindeer" pony rides. They launch the spring season with a dazzling indoor garden display and hold one of the largest sales in the country on the Fourth of July. Tom Dee is a longtime member of the Knights of Columbus and Kiwanis. He was recently honored as Man of the Year at Farmingdale State College for his contributions to the college and the horticulture industry. They are a benevolent family, supporting local, charitable events. Since 2003, Dee's, via Thomas Jr. with support from the Oceanside community, has been running a "Trees for Troops" campaign, shipping Christmas trees, menorahs, and gifts to soldiers in Afghanistan, Iraq, and the Mediterranean. The picture shows, from left to right, Thomas, Joseph, Douglas, Ruth, Elizabeth, Adele, Thomas, Virginia, James, and Steven. (Courtesy of Thomas DiDominica.)

CHAPTER TWO

Educational Leaders

Since education is inherent and necessary for survival, it can be assumed the area's Native Americans, the Rockaways, valued it. They passed, from one generation to the next, their language, fishing and whaling skills, techniques for construction of canoes and dwellings, and their belief in gods. Oceanside's formal schooling goes back at least to the Revolutionary War. During the 1800s, Oceanside had both public and private schooling, with few students, due to Oceanside's small population. It is commonly stated that the school district began in 1833. In its infancy, it served students from Long Beach, Island Park, and Rockville Centre.

High school classes began in 1900. The first high school principal was I.M. Van Valkenberg, who taught seventh, eighth, and ninth grades. In 1911, a beautiful brick structure was built to house students. It later became known as School No. 1 and was located on the site that is now Schoolhouse Green. A population boom in the 1920s saw the construction of Schools Nos. 2, 3, 4, and 5. In 1936, students entered a brand new high school, and School No. 1 became a junior high school. The "new" high school is still in use today. Within it are a preschool, kindergarten, alternative high school, and the department of community activities. The current high school was dedicated in 1954, and an extension was finished in 1965.

The Oceanside School District is soaring at this moment. Oceanside High School is ranked within the top two percent of the nation, according to *Newsweek*. Graduates of the class of 2012 have entered the country's finest colleges, including Northwestern, Harvard, Yale, Brown, Princeton, and Cornell. Oceanside Middle School has been cited nationally by the US Department of Education. It was designated as among the "schools to watch," for being one of the highest-performing middle schools in the nation. The district also prides itself on the arts. The community boasts an outstanding marching band, heralded theater program, remarkable music department, and students who produce masterful works of fine art. The people on the following pages are those who dedicated themselves to the school district's development and success.

Walter Boardman

Dr. Walter Boardman was a man of many facets. His name is legendary to Oceanside people and environmentalists. He was Oceanside's most respected educator, serving as principal and superintendent (1927–1959). He always took time to help people, guiding with wisdom and patience. He was a model of civic leadership. He also was a champion marksman and walked the 2,000-mile-long Appalachian Trail. After retirement, Boardman became deeply involved in environmental issues, especially wetland preservation. He headed the Nature Conservancy from 1961 to 1966. In 1972, he moved to Volusia County, Florida, where he followed his passions until the day he died. He fought environmental causes with a teacher's patience and a preacher's dignity. He had no fear facing companies like Consolidated Edison and Halifax. Because of his activism, a beautiful, tree-lined street in Volusia is now named Walter Boardman Lane. (Courtesy of Hofstra's Long Island Studies Institute and Doris Chwatsky.)

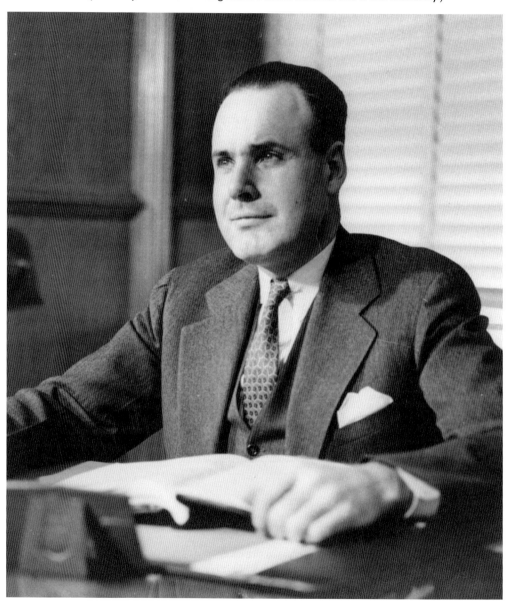

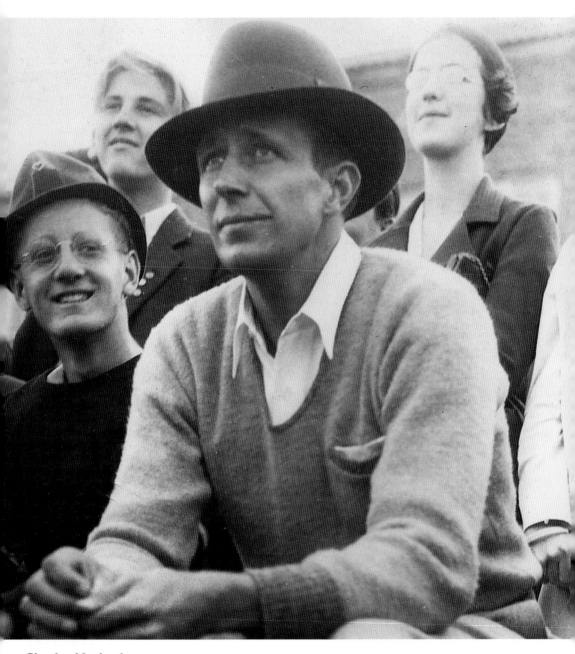

Charles Mosback

No one in the Oceanside School District has ever been more lionized for his affective qualities than Charles Mosback. If true teaching is modeling proper scholarship and citizenship, Mosback was a true teacher. All who speak of him today use words like *integrity*, *loyalty*, *sincerity*, and *kindness*. From 1931 to 1963, he played an integral part in Oceanside High School's evolution from small-town farm community to populated suburb. During his tenure, he increased the number of clubs, sports, and intramural activities. For his devotion to athletics, the football field and Athletic Hall of Fame both bear his name. Within his 32 years at Oceanside, Lieutenant Mosback served his country for two years in the Navy during World War II. He left a legacy of love, patience, and moral character. (Courtesy of Frank Januszewski.)

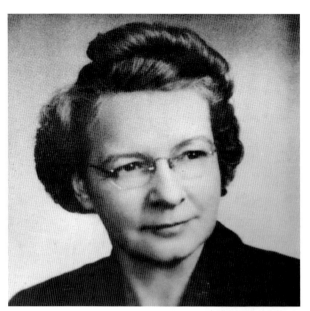

Frances Heinley
Beloved English teacher and nationally recognized thespian coach Frances Heinley was known for her soft disposition and patience. In 1939, with help of her classes, she recorded the first history of Oceanside. Old documents were procured, and citizens were interviewed. It started as a class project but culminated as a tome, titled *A History of the White Man in That Portion of the Town of Hempstead Known as Oceanside.* (Courtesy of the Oceanside School District.)

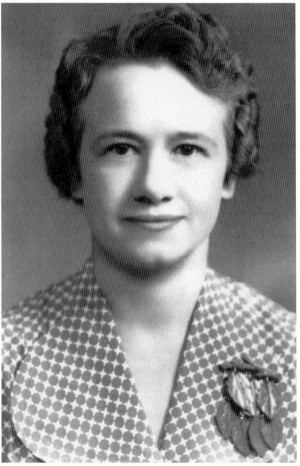

Ruth Lewis
Ruth Lewis was a pioneer. She is remembered as a role model who led by example. She began at Oceanside High School in 1925 as the first girls' physical education teacher. She taught every grade in the school district. From 1925 to 1936, her basketball teams won eight conference championships. She was also instrumental in starting the Long Island Girls Association, a group that organized and promoted girls' interscholastic sports. (Courtesy of Sean Keenan.)

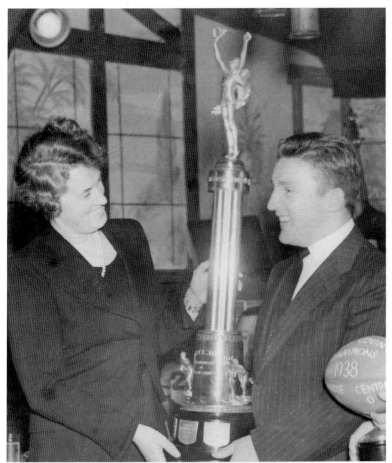

Steven Poleshuk
In 1938, Steve earned All-County for the high school's undefeated football team. The picture shows him receiving the championship trophy from Ruth Lewis. He became an All-American at Colgate. Drafted by the NFL, he enlisted for World War II instead. After the war, he became a teacher, coach, and principal at Oceanside High School. His years as educator and principal were marked with compassion and practical leadership. (Courtesy of the Oceanside School District Archives.)

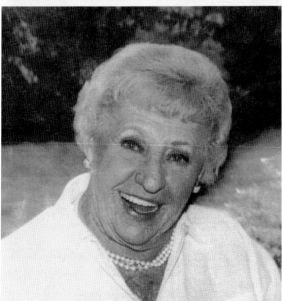

Betty Dunwoody
For 50 years, in administrative and secretarial roles in the Oceanside School District, Betty was there to help. Her energy was geared toward coordination of extracurricular activities, but her indelible mark came from the love she showered upon faculty, staff, and students. She was the first female president of the Rockville Centre Republican Club, a Kiwanis Golden Heart Award recipient, and a member of the Kiwanettes for 25 years. (Courtesy of Hofstra's Long Island Studies Institute and Doris Chwatsky.)

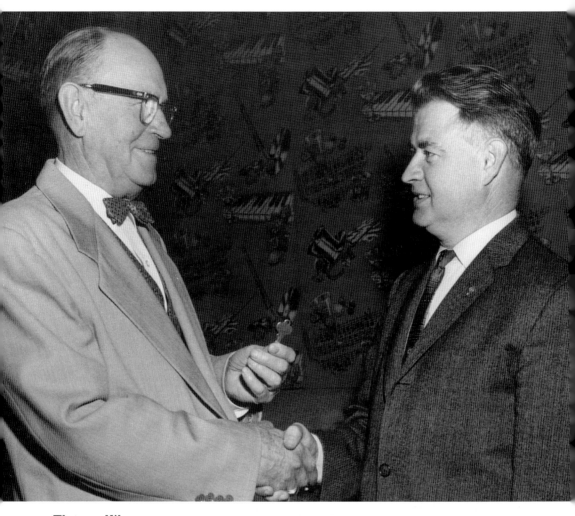

Thomas Kilroy

Thomas J. Kilroy was an educator and humanitarian. He faithfully served Oceanside in numerous educational and charitable endeavors. He was light-years ahead of other educators. As principal of School No. 4 from 1942 to 1972, he pushed for practical learning, group projects, and civic responsibility at a time when rote learning was the norm. He designed summer school to have small classes and an inviting, friendly atmosphere. Science was held outside, lessons were inspiring, and children's opinions were taken into consideration. As a local civic leader and charter member of the Oceanside Rotary Club, he would visit nursing homes, playing the accordion and telling Irish stories. He would do puppet shows for kids at local events and was Scoutmaster of Oceanside's Boy Scout Troop No. 230. He was a two-time Oceanside Citizen of the Year and honored by Rotary Club as a Paul Harris Fellow. He is shown accepting a key to a new wing of School No. 4 from Gus Olsen (left). (Courtesy of Hofstra's Long Island Studies Institute and Doris Chwatsky.)

William Helmcke

An Oceanside High School and New York University football player, William "Bill" Helmcke also was a lieutenant in the Merchant Marines. In 1944, a total of $7,500 in war bonds was purchased in his name during a sportswriter's contest for the "greatest ever" Nassau County athlete. Bill, pictured at right, was a teacher, football coach, and principal remembered for his composed disposition. Bill once said, "Anyone privileged to influence the lives of youth is privileged in affecting the destiny of society." (Courtesy of Michael Limmer.)

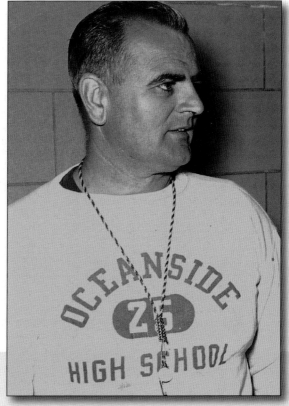

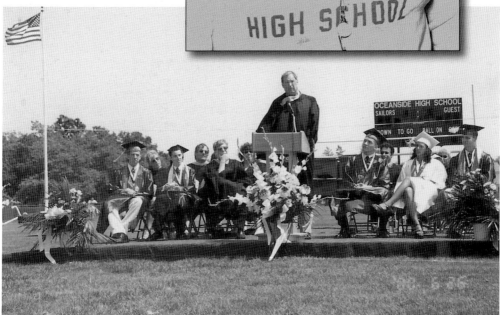

Allenby Lyson

Keeping people on their toes by asking the difficult questions was Allenby "Al" Lyson's modus operandi. He was an influential board member for 18 years, and his banking background helped to make sure the school budgets were sagacious. He facilitated the instruction of foreign language in elementary schools, starting in kindergarten. Oceanside was the first Nassau County School District to institute this. Al, pictured speaking at graduation, retired in 2012; his frankness and honesty will be missed. (Courtesy of Carolyn Lyson.)

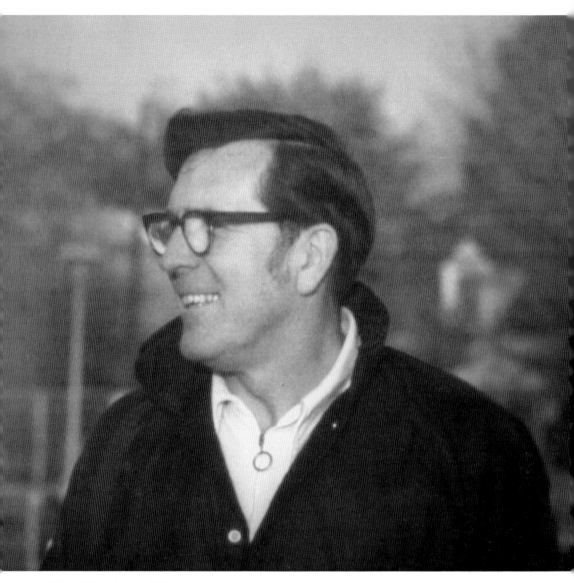

Frank Januszewski

Oceanside is blessed to have Coach Jan. He has done nothing but love this community and its people. He transcends teaching. He embodies the spirit of every endeavor he undertakes. His foresight, creativity, and effort in developing Oceanside High School's Athletic Hall of Fame culminated in a jewel for the high school and the community. "A school that has no past has no future," is one of his credos. Frank is a native of New Britain, Connecticut, and was captain of the basketball team at Springfield College. His basketball knowledge came from his coach, John Bunn, who played for legendary Kansas coach Phog Allen. In 1956, Frank began teaching physical education and coaching. His basketball coaching success has yet to be matched at Oceanside High School. He won five league championships and two county championships in 14 years. (Courtesy of Diane Januszewski.)

Arthur "Artie" Wright

Arthur was a great athlete, playing basketball, baseball, and football at Oceanside High School, earning All-County in basketball. After two years in the Navy, he entered Cortland College, where he played basketball and soccer. He is in Cortland's Athletic Hall of Fame. As an Oceanside physical education teacher from 1950 to 1980, he was known for both his pedagogy and his paddle. He was instrumental in the establishment of Oceanside Little League. He coached four teams and umpired each game. Coach Wright won nineteen division, nine county, and four Long Island championships in soccer. It was with humor, a love for kids, and passion that Coach Wright approached his work. Nobody told a story like Art. He often held court at Pasetti's Luncheonette. His sense of humor belied his genius. He was part Mark Twain and part Knute Rockne. (Courtesy of Jeryl Israel.)

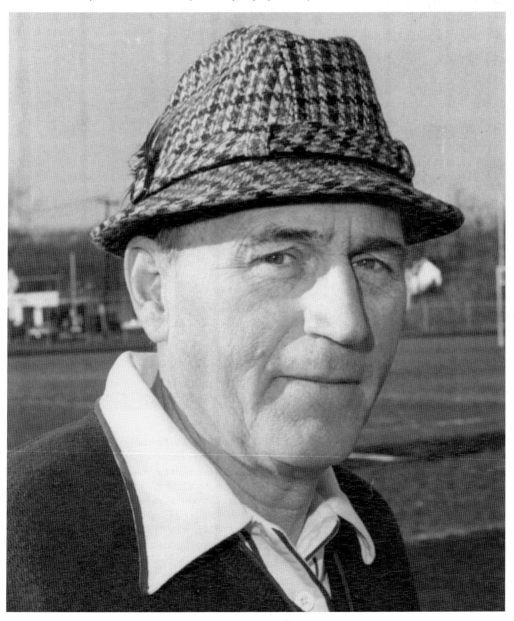

Kenneth Hendler

A Brooklyn boy who was a track star at Lafayette High School and New York University, Kenneth has coached at Oceanside High School for a half century. In 1958, he placed in the New York City High School Championships. In 1964, he qualified for the Olympic Trials in the 200 meters. His tenure at Oceanside is legendary. He is loyal and devoted to his athletes, considering them family. He has won more championships than any other Oceanside coach. (Courtesy of Michael Limmer.)

Barry Kaplan

An English teacher and drama coach, Barry Kaplan touched the lives of many. For 37 years, he cherished his students and they he. He created magic for packed auditoriums on the stage at Oceanside High School, with shows to rival Broadway. Some of his protégés—such as Oscar-winner David Paymer, Tony-winner Joan Stein, and Emmy-winner Bruce Barry—went on to have brilliant careers. All of his protégés treasure the memories. (Courtesy of Barry Kaplan.)

Ned Black

Ned has been inspiring Oceanside students with his love for nature for nearly a half century. His legacy in the school district is excellent teaching, creation of the Nature Study Center, distributing gallon-jug fish tanks, and the feather in his bandana. His Nature Study Center is replete with plants, birds, and aquatic animals. Teachers bring students for interactive projects and investigations. They leave in awe of both nature and Ned. (Courtesy of Justine Woods.)

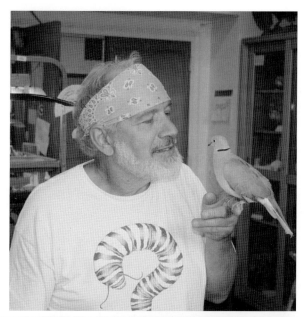

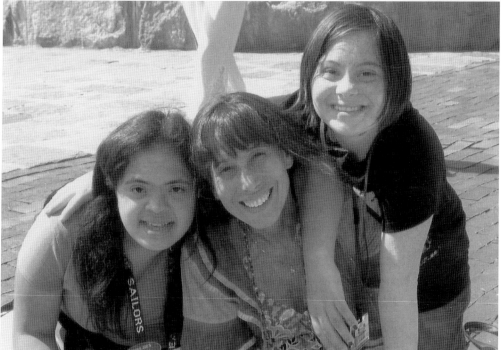

Penny Ellis

Penny models humanity. She and her students have created an ambiance of compassion and understanding in Oceanside High School. Her pedagogy is love. Penny, pictured with Krystal (left) and Regina, works tirelessly to integrate her special education students into every aspect of high school. She has won the New York State Excellence in Teaching Award and the Special Education PTA Heart and Soul Award. In 2011, *Live! with Regis and Kelly* honored Penny as America's Top Teacher. (Courtesy of Penny Ellis.)

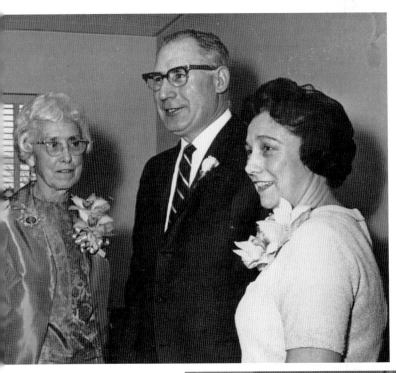

Florence A. Smith

Florence Alice Smith's career in Oceanside as a teacher and principal lasted 40 years. She was regarded as a stern but caring educator. In the words of 1965 Oceanside School Board president Arthur Iger, "The affection, esteem and loyalty Miss Smith evoked is extraordinary evidence of her influence. She personified to all the highest values and aspirations of public education." Terrell Avenue School was renamed in her honor in 1964. She is pictured (left) with John Vandermosten and Carol Sewell, her successor. (Courtesy of the Oceanside School District.)

Frank and Julia Nappi

Julia is a dedicated, compassionate, spirited social studies teacher who served 10 years as the director of Student Projects. She worked tirelessly so that events proceeded smoothly. Her welcoming office was a respite for students. Frank, a respected high school union vice president and beloved English teacher, is also a venerated novelist. *Echoes from the Infantry*, *The Legend of Mickey Tussler*, its sequel, *Sophomore Campaign*, and *Nobody Has To Know* are his acclaimed works. (Courtesy of the Nappi family.)

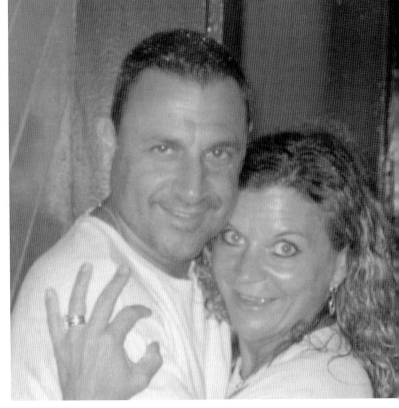

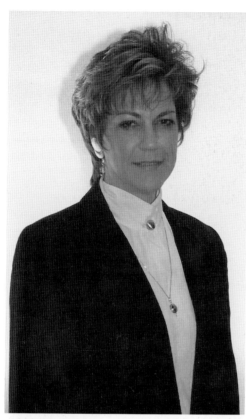

Maryanne Lehrer

The advent of this book coincides with the retirement of one of Oceanside's greatest school board members. Maryanne served 36 years, acting as president five times. She was also a member of the Nassau-Suffolk School Boards Association, often presenting its views on WLIW/Channel 21. A University of Michigan graduate, her career in school politics started with School No. 2's PTA. She won her first school board election in 1977. In the early 1980s, she was a major force behind the creation of Oceanside Middle School, which embraced a new philosophy of education. In 1985, she led a successful campaign, convincing the board of regents to ban corporal punishment in New York State public schools. She has been chosen Woman of the Year three times by Oceanside organizations. Maryanne Lehrer enjoys any and all school events. Below is a picture of the 2011–2012 school board. Members are, from left to right, (sitting) Kim Grim-Garrity, Robert Transom, and Allenby Lyson; (standing) Mary Jane McGrath-Mulhern, Donald Maresca, Maryanne Lehrer, and Sandie Schoell. (Left, courtesy of Maryanne Lehrer; below, courtesy of Donna Krauss of the Oceanside School District.)

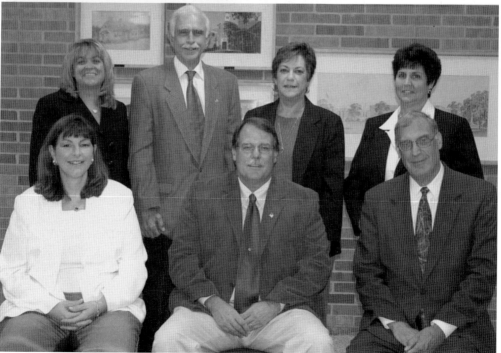

Dr. Herb Brown and Riche Roschelle

These two men have worked together to move the school district forward, always considering children first. Dr. Brown, pictured at left, keeps an open mind for the introduction of new ideas. He believes that with its clubs, sports, and social activities, Oceanside School District has something to offer for all students. Only Dr. Boardman has served as superintendent longer than he. Under his leadership, Oceanside has gained full-day kindergarten and foreign language in the elementary schools. Riche Roschelle, at the microphone below, has tirelessly used his position to create a humane environment in the schools, improving morale and spirit. He fights for what he believes is right for students and teachers. Riche and Dr. Brown have built a trust, which includes 16 years of smooth contract negotiations. Most recently, this collaborative effort is evident with Oceanside's new teacher evaluation, the APPR Agreement. (Both, courtesy of Donna Krauss and the Oceanside School District.)

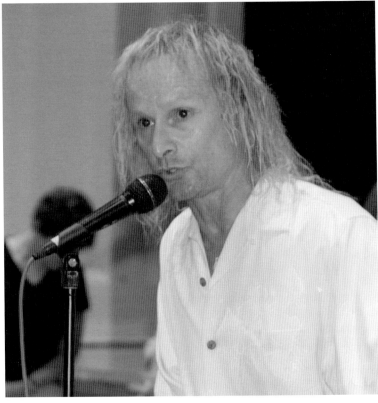

CHAPTER THREE

Prominent Citizens

The people in this chapter run the gamut from being nationally recognized successes to locally significant citizens. These people either grew up in Oceanside or spent their adult years here. The United States and the world could not exist without these citizens from Oceanside. This little town significantly influenced civil rights, women's suffrage, the initial medicinal treatment of HIV, national economic policy, rock and roll, the New York Yankees' lineup, Disney entertainment, the policy of the US Navy, and the development of XM Satellite Radio. In this chapter, Oceanside's victims of 9-11 are also recognized and remembered; they are still loved and missed dearly.

COLORED WAITING ROOM
INTRASTATE PASSENGERS

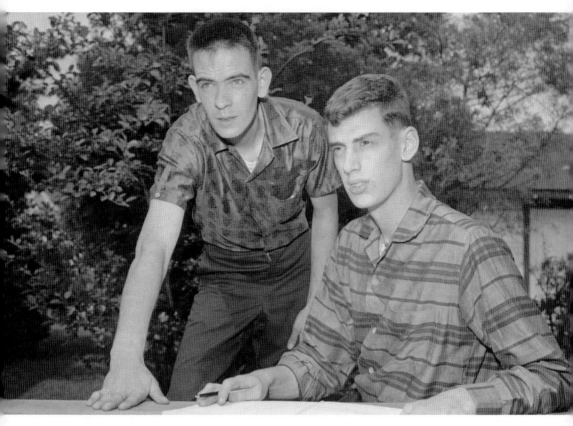

Joseph McDonald and Kenneth Shilman

If someone asked Joseph McDonald if he were a hero, he would say no. Yet, he was willing to risk life and liberty to help end racial discrimination down South. In 1961, 19-year-old Joe was part of a group of black and white citizens known as Freedom Riders. Joseph and his best friend, Kenneth Shilman, both grew up in Oceanside and felt humanity in the country was lacking and decided to act. They traveled by bus from north to south, disobeying the Jim Crow Laws. On the buses, blacks and whites would share seats and blacks would sit up front. When the bus stopped at depots down South, blacks would sit in the white waiting area and vice versa. Joseph and Kenneth were arrested, with others, in Jackson, Mississippi, for sitting in a black waiting area. The picture at left depicts this event. Kenneth is in the foreground, and Joseph is behind him. They were sentenced to a $500 fine and two months in jail. At one point, while being moved to another prison facility, one of their fellow "riders" refused to go voluntarily. He was dragged on concrete, and his skin was scraped bloody. Later, while they were relaying the man's ordeal to the FBI, the agents quipped sarcastically, "So you guys are the heroes from Oceanside." They are seen in the picture on page 39 getting interviewed in Joseph's backyard by the *New York Times* after returning from the Freedom Rides. Getting involved changed Joseph's outlook on everything. He and Kenneth both became committed to change. They became activists in the anti–Vietnam War movement and in every cause they could find. They were asked by the Congress of Racial Equality (CORE) to speak at black churches to raise awareness. Kenneth joined the Socialist Workers Party and became extremely active. His activism led to many death threats, and Joseph was beaten more than once for his beliefs. The FBI followed them everywhere and once visited Joseph's grandmother's house in Oceanside. Although Kenneth had passed away, Joseph, among others, was honored in 2011 on the *Oprah Winfrey Show* for the 50th anniversary of the Freedom Rides. Joseph has said he would not change his life for anything. Although he never acquired wealth, he felt he gained riches for his soul from his deeds of altruism. (Both, courtesy of the Associated Press.)

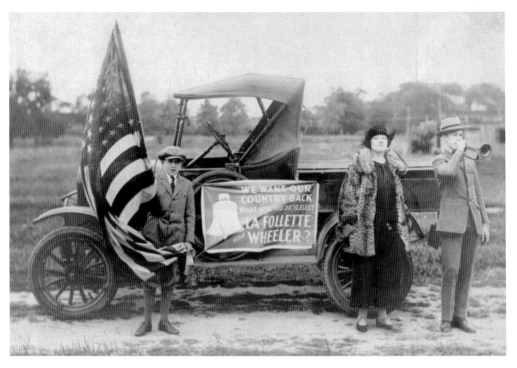

Jeanne Marion Doane

Jeanne Marion Doane was a force to be reckoned with. She immigrated at 10 years old from Denmark with her mother and two sisters and worked in a Manhattan popcorn factory, earning $1 a week. She received no formal education but managed to learn how to read and was apt to memorize passages of Shakespeare. Her intelligence and energy eventually led to a job with New York City mayor William Gaynor as his private secretary. She studied stenography and was the first woman stenographer in a US district court. She studied law and was admitted to the bar in 1908. She advocated for the disadvantaged, speaking publically against child labor and for women's right to vote. Her memories of slaving dawn to dusk in a sweatshop, as a little girl frenzied to finish her work, motivated her activism. In 1925, her law firm wrote a letter to every senator and assemblymen for ratification of the Child Labor Amendment. It passed the House and Senate but was not ratified by enough states to become an amendment. Speaking against the status quo had its moments. She had a cross burned at her Oceanside home by the Ku Klux Klan, who opposed her advocacy of immigrants. Once, while speaking in East Quogue, she had a baseball thrown at her head. In 1926, she ran for New York State Assembly, losing to Edwin Wallace. She was a Democratic state committeewoman and vice chairperson of the Nassau County Democratic Committee. One of her victories was lobbying for the passage of an amendment to the Code of Civil Procedure, which allowed alimony to be readjusted if a divorced woman needed additional support. She fought successfully when neighboring communities wanted to open a garbage dump and waste incinerator in Oceanside. Doane's 30-acre Oceanside farm was located where Oceanside Middle School exists. Jeanne, with her son Ralph, had a real estate company, Domar Developers, Inc. The canal in the area is named the Domar Canal (a contraction of Doane and Marion). Always philanthropic, she leased land to South Side Hose Company No. 2 for $1 a year, paying the first two years' rent herself. According to her grandson, Alice and Beatrice Avenues are named after relatives. Carrel Boulevard was named after Dr. Alexis Carrel, for whom she was secretary during World War I. Jeanne lived in Oceanside until her death on August 10, 1947. The picture shows her with color-bearer Edgar Hatfull and bugler Edward R. Burmester. They are campaigning for 1924 presidential candidate Robert La Follette, from the Progressive Party. (Courtesy of Ralph Marion Jr.)

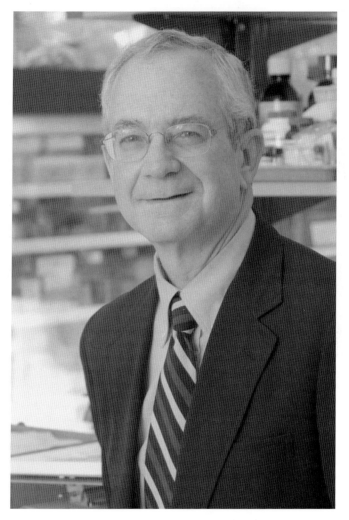

Dr. Robert Yarchoan

The worldwide HIV/AIDS pandemic killed nearly two million people in 2010. The first treatment that was successful in slowing the spread of HIV was AZT, or azidothymidine. In 1985, at the National Cancer Institute, Dr. Robert Yarchoan ran the first clinical trials with this drug against HIV. The AZT clinical trials and Yarchoan's coinventing and developing other antiretroviral drugs make him one of Oceanside's greatest heroes. At Oceanside High School, he was a member of the National Honor Society and JETS (Junior Engineering Technical Society). He played clarinet in the school band and the Nassau County Orchestra and had a passion for surfing. He attended Amherst College and then the University of Pennsylvania Medical School. In the early 1980s, while working at the National Cancer Institute, he and his colleagues were among the first scientists to recognize the advent of HIV/AIDS as a prolific plague. Since then, he has devoted his life to prolonging the lives of people afflicted. He is the head of the Retrovirus Disease Section at NCI. He has been awarded the US Public Health Service Outstanding Service Medal and was a recipient of the first National Institute of Health World AIDS Day Award in 2006. In 2007, he received the National Cancer Institute's HIV/AIDS Research Excellence Award with the colleagues with whom he worked battling AIDS in the 1980s. "AIDS has given me an opportunity to make a difference. I wish that opportunity was not there, but I am glad I was able to do something about it," said Dr. Yarchoan. (Courtesy of National Institutes of Health.)

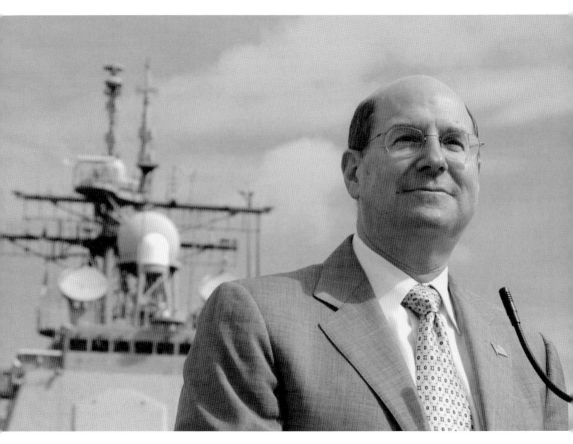

The Honorable Donald C. Winter

The boy who boated and fished for flounder in the bays around Oceanside became the man who led the US Navy from 2006 to 2009. Secretary of the Navy Donald Winter's love for electronics and technology culminated in bachelor's, master's, and doctoral degrees in physics. The latter two degrees came from the University of Michigan. After working for the aerospace technology company TRW during the 1970s, he did research for President Reagan's Strategic Defense Initiative. For his work, he was awarded the Secretary of Defense's Medal for Meritorious Civilian Service. He returned to TRW, working on space systems activities that supported the national defense effort. He eventually became CEO of TRW Systems, a division of TRW. After TRW's takeover by Northrop Grumman, he became president of Mission Systems, which was created from TRW Systems and similar parts of Northrop Grumman. In 2005, he was selected by Pres. George W. Bush to be Navy secretary and confirmed by the US Senate. He was sworn in January 3, 2006, and continued as Navy secretary through the beginning of the Obama administration. He remembers Oceanside as a place of neighborly people with diverse backgrounds. He said, "Oceanside people weren't rich, but generous with their time." He credits two high school teachers, Martin Rudolph and Russell Falzone, for fostering his love of math and physics. Secretary Winter's brother Matthew is president of Allstate Home and Auto Insurance, and his sister Jane is a professor at Northwestern Medical School—not bad for three kids from Oceanside. Secretary Winter teaches at the University of Michigan and is a member of the National Academy of Engineering. (Courtesy of Donald C. Winter.)

Robert Iger

Fortune and *Forbes* magazines consistently name him one of the most powerful men in media, but he humbly refers to himself as "Bob Iger from Oceanside." Riding a bicycle through his Ocean Lea neighborhood to the Red Store, walking with School No. 8 classmates to Nathan's, and playing recreation basketball for the beloved Bill Zener are fond recollections Bob has of the community, which has remained near and dear to his heart. Bob's parents were models of civic responsibility. Arthur, a war veteran, and Mimi, who worked at Boardman School, were both involved in community affairs. Arthur served as school board president. Active in high school, Bob was the president of the service organization, Key Club, and would announce the football and basketball games. He was voted "Most Enthusiastic Student" in 1969. After graduating from Ithaca College in 1973, he was hired by ABC. Over a couple of decades, he worked his way up from television weatherman to chief operating officer of ABC's corporate parent, Capital Cities/ABC. In 1996, The Walt Disney Company bought Capital Cities/ABC, and he became president of Walt Disney International. He became chief operating officer for Disney in 2000. Since becoming Disney CEO in 2005, he acquired Pixar and the comics and movie company Marvel Entertainment. He expanded Disney's theme parks and increased international interest in the company. The company has been consistently considered a model for corporate action and he an exemplary CEO. He is revered for his vision, discretion, and demeanor. Robert Iger, like his parents, has an erudite view and serves his country in many ways. He was appointed by Barack Obama to the President's Export Council and is on the United States–China Business Council. He is on the boards of the National September 11 Memorial and Lincoln Center for the Arts, New York City. In 2012, for his philanthropy and leadership, he was presented the Ambassador for Humanity Award from the Shoah Foundation Institute, a nonprofit organization whose mission is to overcome prejudice, intolerance, and bigotry. Bob is married to journalist Willow Bay, and he has four children—Jake, Payton, Gavin, and Sarah. (Courtesy of Disney Corporation and Stephanie Voltz.)

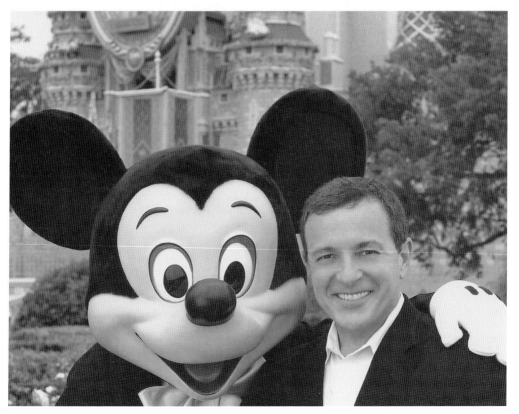

Steve Friedman

Steve's Oceanside High School classmates knew him as an outstanding wrestler and the boy they voted "Best Looking." Physical education teacher Frank Januszewski knew Steve as the boy whose father purchased sneakers for needy children. George W. Bush knew him as his chief economic advisor and chairman of the US Foreign Intelligence Advisory Board. In 1959, he graduated from Cornell University and won the Eastern Intercollegiate Wrestling Championship at 157 pounds. After graduation, he wrestled for the New York Athletic Club and won an Amateur Athletic Union national championship. He received a law degree from Columbia University. In 1966, he started a career with Goldman Sachs & Co. and became a partner by 1973. He eventually became its chairman. In 1984, he was recognized by the NCAA for his achievements and was also inducted into the Cornell Athletic Hall of Fame. He serves today on the boards of Goldman Sachs, Sloan-Kettering Cancer Center, and the Aspen Institute. He is pictured below (at left) winning the South Shore High School Championship while at Oceanside High School. (Right, courtesy of Steve Friedman; below, courtesy of Frank Januszewski.)

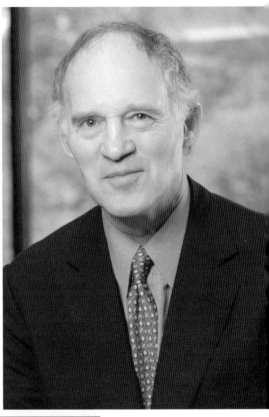

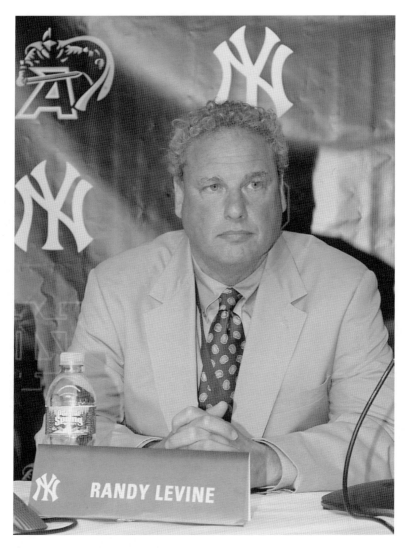

Randy Levine

Oceanside High School 1973 graduate Randy Levine lettered in both basketball and football. Nicknamed "Buffalo," he was a rugged football lineman. He also played college basketball for the George Washington University Colonials. His baseball success came later. He received degrees from George Washington and Hofstra University Law. In the game of negotiation, one wants Randy on his or her side. He gets the job done. He took on the Teamsters Union and the Palestinian Liberation Organization while working for the US attorney general during the Reagan Administration. He negotiated contracts with teachers, hotel workers, and commercial real estate developers as a labor commissioner and deputy mayor for New York City mayor Rudolph Giuliani. In 1996, he represented the Major League Baseball owners, reaching a landmark agreement with the players' union. Since 2000, he has been president of the New York Yankees, and his victories continue. He helped create the YES Network and directed all the development and financing of the new Yankee Stadium. His influence is felt in many places, and his résumé would take another chapter in this book. He is a senior counsel at Akin Gump Strauss Hauer & Feld LLP. He even has an Emmy to his credit for his *Forbes Sports Money* show on YES Network. Randy, with his wife, Mindy, is involved in numerous charitable causes and may have more victories than Whitey Ford before he retires. (Courtesy of Stephanie Fullam and Randy Levine.)

Norman Pickering

In the 1940s and 1950s, Pickering was the local Thomas Edison. At Pickering & Co. on Woods Avenue, he developed a magnetic cartridge with a sapphire needle improving the audio quality of LP records. It amplified sound with less noise. Rock stars owe this genius a debt of gratitude. After a day's work, Norman would relax, playing nine holes on the Oceanside Golf Course. A gifted musician, he plays the violin and French horn. He attended Newark College of Engineering and then Julliard. His engineering and music careers are meshed. He has devised improvements to enhance instruments and played in the Indianapolis Symphony. His research on violin acoustics, improving the quality of string bows, is significant. His first patent improved the French horn. Other patents have advanced numerous professions. At 96, he is still striving to craft that "ideal sound." (Courtesy of Norman Pickering.)

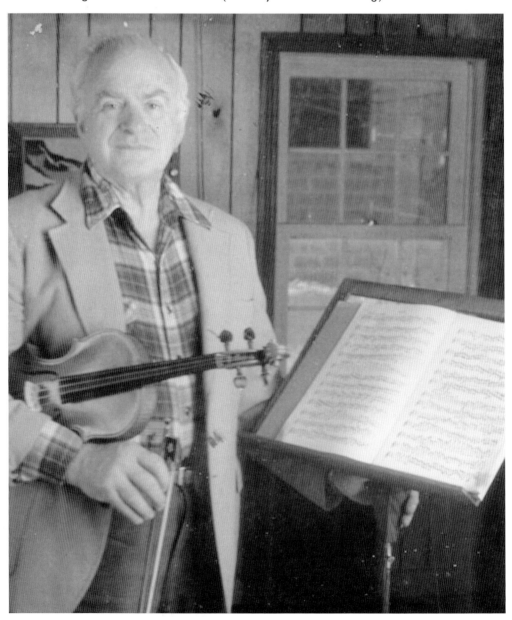

Charles Beall

This millionaire banker had a strange hobby—collecting exotic animals. From 1927 into the 1930s, he kept them in a zoo he constructed in Oceanside behind Mott Street. It was the largest private zoo in the country. It had a carousel, cafeteria, and a pavilion for dancing. He delighted in giving children rides on elephants, llamas, and giant turtles. Beall died in his house on the zoo grounds in 1939. The picture shows the old elephant hole behind Wright's Field, where his elephants would take a bath. (Courtesy of Julia Woods.)

Tracy Noon

Oceanside's favorite and most lovable clam-digger will be remembered for riding his bicycle, collecting artifacts, and cheering high school sports. The youngest of 12 children, he grew up on a farm near Roosevelt Street. He never tired of talking local history and was proud of his family's roots. His grandparents were born in Christian Hook in the early 1800s. Tracy's spirit for living was a gift enjoyed by all. (Author's collection.)

Deborah Pearsall

If people leave their marks on this world after a lifetime, they are significant. If their lifetime is 21 years, they are legendary. There was no stopping Debbie Pearsall. She moved fast-forward with enthusiasm, intelligence, and a sense of humor for every task. At Lehigh University, journalism was her passion. She wrote articles for the school newspaper, the *Brown and White*, that touched people's hearts and made them pause to reflect. Once, she traveled with campus police officers during their shifts for a piece, which allowed students see police officers in a new light. Her last story at Lehigh was to be about Centralia, Pennsylvania, where a fire at an abandoned mine pit ignited underground anthracite and has been burning for 50 years. She was giving up her spring break to travel there for research. She was poised to become the Woodward or Bernstein of her time. At Lehigh, she was considered the school's den mother; everyone knew her, and she had her hand in every pot. She was the editor-in-chief of *Brown and White* and interned at *Newsday*, *Men's Health* magazine, and *News 12 Long Island*. At Oceanside High School, Debbie was a member of the National Honor Society, an All-County track-and-field athlete, and the founder of the powder-puff football game between junior and senior girls. The game is run for charity. At graduation 2012, Lehigh president Dr. Alice P. Gast recalled her as "the most dynamic woman ever to attend Lehigh." (Courtesy of Jason Manning.)

Barry Littman
At Oceanside High School, no one could predict whether Barry's path would lead to football, rock and roll, or a professorship, but all predicted success. He graduated Harvard University and Georgetown Law. He became the head of business and legal affairs at Miramax Films, brokering deals to finance films. He now represents people in all aspects of entertainment. In 2006, he became a Universal Life minister and presided over Diane Farr's wedding. (Courtesy of Barry Littman.)

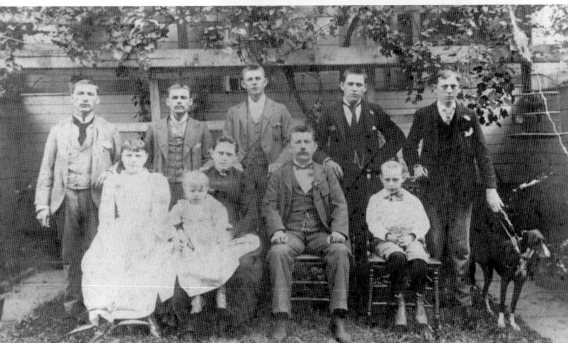

Anton Wettach
Anton made money owning a slaughterhouse in Manhattan. He spent it in Oceanside. He owned all the property where Oceanside High School exists and the land where Temple Avodah is today. Oceanside was his respite away from the city. The picture shows his house on Foxhurst Road, his wife, and eight of his thirteen children. His descendant Carol Croce was an Oceanside teacher and librarian for 30 years. (Courtesy of Carol Croce.)

Joan Walsh

When television host Chris Matthews from *Hardball* needs a person to shoot from the hip about current political topics, he chooses the scholar and intellectual Joan Walsh. She lived in Oceanside until 13, attending St. Anthony's School. She currently is the editor-at-large of the online magazine Salon.com. Her views are liberal, and she's been known to mix it up with the likes of Bill O'Reilly or Pat Buchanan. (Courtesy of Joan Walsh.)

John Valenti

At Oceanside High School, John had a sharp eye as the All-County captain of the rifle team. As a *Newsday* reporter, he has a sharp eye for a story. He, looking sharp with a buzz cut in the picture, is a five-time Pulitzer Prize nominee and has received numerous honors for groundbreaking and investigative reporting. His talent is evident in his 1991 book *Swee'pea and Other Playground Legends*. According to *Kirkus' Reviews*, it is "a perceptive, gloves-off look at an inner-city tragedy." (Courtesy of John Valenti.)

Betty Robbins

In 1932 Poland, when Betty was eight years old, she was not allowed to sing in the boys' choir during synagogue. So she sat opposite the boys and sang so loud that the cantor relented. Twenty-three years later, she had a similar but more significant experience. Amid worldwide controversy, she was appointed by the board of Temple Avodah to serve as cantor, the first in 5,000 years of Jewish history. (Courtesy of Judd and Sandra Robbins.)

Arthur Eldred

In a barn on Terrell Avenue began Oceanside's Boy Scout Troop No. 1. Hubert Eldred was Scoutmaster, and his brother Arthur a member. After receiving 21 merit badges, he was tested by local and national representatives to confirm his qualifications. He became America's first Eagle Scout in April 1912. He received Oceanside High School's first Regents diploma and attended Cornell University. In the photograph, Arthur is showing off his badges in front of his house. (Courtesy of Willard Eldred.)

Ron Ross

Ron retired from a career in real estate at age 70. He then exploded with a prolific production of boxing books. The acclaimed *Bummy Davis vs. Murder, Inc.*, and Emil Griffith's biography, *9, 10, and Out*, are available in bookstores. His latest work is *Tales from the City of New York*. He is a member of the Long Island Jewish Hall of Fame and the Florida Boxing Hall of Fame. (Courtesy of Lisa Ross.)

Steve Cohen

After graduating from the University of Massachusetts, Steve did a headfirst dive into baseball without looking back. He started working for minor-league teams in St. Petersburg, Florida, and, since 2000, he has been the general manager of the Brooklyn Cyclones. He has a heart of gold, and via the Cyclones has donated to many charitable causes. In 2009, he received the Mets' Sterling Minor League Executive of the Year Award. (Courtesy of Steve Cohen and Michelle Feibusch.)

Lon Levin

XM Satellite Radio improved the quality and content of radio. For this, Oceanside High School's 1973 General Organization president, Lon Levin, can be thanked. He is proof that tiny acorns from Oaks School No. 3 grow to be mighty oaks. He cofounded XM Radio, serving as its president from 1992 to 1998. He has facilitated the formation and development of numerous satellite media and wireless companies. He is a lawyer, executive, and entrepreneur and has served on the Defense Business Board for the US Department of Defense. A member of the NASA Space Technology Hall of Fame, he is president of Sky Seven Ventures, which invests in space, new media, and telecommunications industries. He serves on the board of directors of the Cultural Development Corporation of Washington, DC. He is a sought-after speaker for industry, academic, and government conferences on new technology business, policy, and finance. (Courtesy of Lon Levin.)

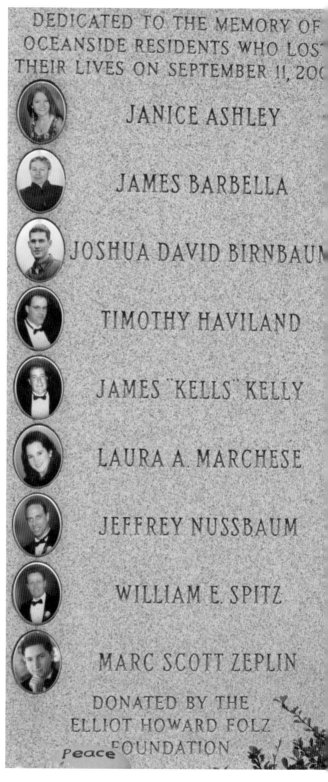

DEDICATED TO THE MEMORY OF
OCEANSIDE RESIDENTS WHO LOS
THEIR LIVES ON SEPTEMBER 11, 200

JANICE ASHLEY

JAMES BARBELLA

JOSHUA DAVID BIRNBAUM

TIMOTHY HAVILAND

JAMES "KELLS" KELLY

LAURA A. MARCHESE

JEFFREY NUSSBAUM

WILLIAM E. SPITZ

MARC SCOTT ZEPLIN

DONATED BY THE
ELLIOT HOWARD FOLZ
Peace FOUNDATION

Philip Martiny
In 1895, the schoolhouse on Foxhurst Road was deemed too small for use. Martiny purchased it and moved it to Terrell Avenue. Many of his masterpieces were created there. He was a prolific sculptor. The Surrogate Courthouse on Chambers Street, Manhattan, displays his sculptures of New York officials from 1640 to 1888. The staircases of the Great Hall in the Jefferson Building of the Library of Congress are flanked with his carvings. (Courtesy of the Archives of American Art.)

Remembering 9-11 Loved Ones
Oceanside lost 14 people during the attacks on the World Trade Center on September 11, 2001. They were fathers and mothers, friends and classmates, sisters and brothers, and daughters and sons. Aside from the firefighters who are honored in chapter eight, their names appear next to their pictures. The picture is of a memorial monument on Davison Avenue across from the library. (Author's collection.)

CHAPTER FOUR

Civic and Religious Leaders

This chapter contains saints, angels, and advocates. These are people whose thoughts and actions are tied to the well-being of others. They are leaders who alleviate local problems, initiate community-building events, provide activities for children and the elderly, and advocate for the less fortunate. Neighbors on these pages are at every fundraising event, every walkathon, every phone-a-thon, and every dinner for charity. They are youth coaches, food pantry workers, volunteers, and Scout leaders. Many are members of religious and altruistic organizations whose sole purpose is philanthropy. This chapter also features Oceanside's religious leaders. Some are historical figures and others are current. Some are laity whose service to their places of worship warrants their inclusion. Oceanside clergy are omnipresent and lead by example. They are welcomed everywhere, including the schools. Oceanside is fortunate to have such caring religious leaders. Oceanside's Interfaith Council is an example of Oceanside's commitment to civility among people. It deals with civil rights, social action, and diffusion of community unrest.

Kathy and Robert Towers

Giving is in the hearts of Kathy and Robert Towers. Both work selflessly for the community. They model civic responsibility with a loving and caring demeanor. The couple is involved in community beautification, improvements in local commerce, teaching Sunday school, facilitating school clubs and events, and numerous charities. Kathy worked with youth via the Oceanside Department of Community Activities for over 35 years. At the First Presbyterian Church, she founded and maintains the Family Closet, which reaches out to help individuals and charities. A graphic designer, Kathy was responsible for the conceptual design sketches of Liberty Lighthouse as well as the Triangle Project. Robert, as the chamber of commerce president and liaison, conferred with Nassau County over eight years, seeing the Triangle's face-lift to fruition. He is a Vietnam veteran and true patriot. As an officer of the chamber of commerce, he arranged ceremonies honoring the fallen Oceanside soldiers. Ceremonies were held at the Oceanside Veterans' Triangle with veterans' organizations and honored soldiers' family members present. His kindness to the families of 9-11 victims was exemplary. Robert and Kathy have been honored and have received every community award but remain a grounded, humble, giving couple. Their daughter Kimberly is becoming a legend in her own right. She is one of the top fashion designers in the country. She has her own line of original, custom couture evening gowns. Her designs have been worn at the Oscars, the SAG Awards, and the Grammys and have been seen on *Real Housewives of New York City.* (Courtesy of Bob Towers.)

Betsy and Bob Transom

Betsy and Bob make things happen. Bob's experiences as a businessman, civic leader, and Army veteran give him a great perspective of what the community needs, and he gets it done. He has been a school board trustee for 15 years, serving three terms as president. A lifetime member of the American Legion, he also serves on the board of Oceanside Stallions Football. He and Betsy work side by side in Oceanside Community Service and the Kiwanis Club. Betsy is fueled with energy, always looking to improve the neighborhood. Her brainstorm led to the creation of the beautiful, serene Schoolhouse Green. As president of the Oceanside Educational Foundation, she works to preserve and bring to light the community's history. They live by the following credo: "You have not lived until you have done something for someone who can never repay you." (Courtesy of the Transom family.)

Al Cullinane

In 1949, Walter Boardman started Oceanside Community Service after recognizing Oceanside had many disadvantaged families. Al Cullinane, pictured with his late wife, Anne, has been a member for 55 years. Three different civic organizations have named him Citizen of the Year. He is a past president of the Kiwanis Club and also was president of the Oceanside Teachers Association. Oceanside Community Service raises money via donations and an annual dance. It turns those donations into smiles for needy citizens. (Courtesy of Maria Heller.)

Frank Ford

Frank Ford, with Joseph J. Garay, spearheaded the effort to create the Knights of Columbus. Starting in 1952, they met periodically at Evergreen Firehouse, moving to their own building in 1962. Andrew Hickey became the first Grand Knight. They support charities, conduct fundraisers, and run blood drives. Their lounge is a place for collegial respite. Frank owned Vernon Printing in Oceanside and was pivotal in the formation of Oceanside Christopher Federal Credit Union. (Courtesy of the Knights of Columbus.)

Nancy Baxter

Nancy is a fulcrum for the wheel of people who keep this community moving. She has taught at Loving and Learning Educational Child Care and Oceanside's Kindergarten Center. Since 2005, she has been the coordinator of all youth activities for the department of community activities. She and Maria Bavaro form an unbeatable team. In 2008, Nancy broke the gender barrier when she became the first female president of the Kiwanis Club. Previously, she had been Key Club advisor at Oceanside High School. Her goals as president were to promote Kiwanis Club, bring to light its community involvement, and increase club membership. Kiwanis Club sponsors many Oceanside events including Halloween Window Painting, a Spring Egg Hunt, the Roller-Skating Show, and December's Holiday Happenings. It sends kids from Oceanside, who would otherwise not be able to pay, to Kamp Kiwanis for a week of activities and comradeship. Kiwanis has the "K" Kids Club in elementary school, the Builder's Club at Oceanside Middle School, and the Key Club at the high school. These clubs teach the importance of service to community in the Kiwanis Club tradition. Student members volunteer at all events and help in preparation. One of the Kiwanis Club's largest fundraisers is the Pancake Breakfast on the morning of the Super Bowl. Oceanside is lucky to have Nancy, such a caring citizen, who gives freely and helps to fuse the network of organizations in Oceanside so that local children can reap the benefits. (Courtesy of Nancy Baxter.)

Syed Majid

Some engineers buy mansions. The late Syed's treasures were his wife and daughters. Open the phone book to "Service Organizations" and check off Syed as a member of each—Hose Company No. 2, Kiwanis Club, Oceanside Community Service, and so on. A Korean War veteran and Oceanside's Citizen of the Year in 1992, he regularly volunteered to drive veterans to doctor appointments. Robert Transom said of Sy, "He was the hardest behind-the-scenes worker and volunteered more time than anybody." (Courtesy of the Majid family.)

Maria Heller

Maria is the first to lend a hand. She is a PTA Lifetime Member, Methodist church volunteer, former 4-H Club leader, promoter of charitable events, and the first female in the Kiwanis Club. Maria has been Oceanside's Citizen and Businesswoman of the Year, as well as Long Island's American Businesswoman of the Year. She was the production manager of the *Oceanside Beacon* for 15 years and has her own business, Publicity Plus/ Minuteman Press. (Courtesy of Maria Heller.)

Tony and Angela Iovino

Angela is a two-time president of the Kiwanettes, president of the library board, and treasurer of the Oceanside Education Foundation. Tony served on the Oceanside School Board and is a past president of the Kiwanis Club. He has won the Town of Hempstead's Make a Difference Award and Oceanside's Citizen of the Year. During the summer, they cohost Gazebo Readings at Schoolhouse Green, a beautiful way to spend Monday nights. (Courtesy of the Iovino family.)

Sandie Schoell

Sandie, with husband, Gary, moved to Oceanside because of its caring community and reputable school system. She has improved both. She is the 2012–2013 school board president and has volunteered for more than a dozen civic organizations. Making a difference is her modus operandi. She has won Citizen of the Year and the PTA's Heart and Soul Award. The Schoell boys, Michael and Christopher, were both Oceanside High School valedictorians. (Courtesy of Sandie Schoell.)

Betty Ahern

Betty was the supervisor of the department of community activities from 1955 to 1985. She managed its development and increased its scope as the population of Oceanside's youth exploded. Betty, at far right in the picture, created a Teen Center and added many new activities to meet children's needs. Under her leadership, the recreation department grew into a highly respected organization with enormous numbers of participants. She was a member of the New York State Board of Recreation and Parks. During her "spare time," she was president of the local American Businesswomen's Association and treasurer of the Long Island Association of Recreation and Parks. As an Oceansider herself, she was vested in working for the people she loved. Her impact on Oceanside was acknowledged with a Kiwanis Citizenship Good Guy Award and a PTA Lifetime Membership Award. This community still reaps the benefits of her vision and leadership today. (Courtesy of Barbara McGuinness.)

Arnie Preminger
Oceanside's greatest treasure is the Barry and Florence Friedberg Jewish Community Center (JCC). The president and CEO for this outstanding agency is Arnie Preminger. For 27 years, he has helped to provide health, education, recreation, and entertainment for the community. The JCC serves the old and young of all denominations. There is no better evidence of the value of this organization than its Sunrise Day Camp, dedicated to children with cancer. (Courtesy of Arnie Preminger.)

Buddy Epstein
Buddy Epstein, of the Oceanside Jewish War Veterans, gives of himself daily. He visits schools via the Tell America program, educating children about the realities of war. He, with post commander John Robbins and post members, runs barbecues, visits hospitals, and raises money for veterans' charities. The organization awards a scholarship yearly to the Oceanside High School student who best composes an essay titled "Why I am Proud to be an American." The picture shows, from left to right, Dean Skelos, John Robbins, and Buddy Epstein. (Courtesy of Buddy Epstein.)

Mary Pearson

When the Nassau County Medical Society suggested the building of a hospital near Rockville Centre, Mary Pearson, RN, with businessman George D.A. Combes created one. In 1928, South Nassau Communities Hospital opened. She worked as a nurse and hospital superintendent. She worked 51 years and volunteered for many more. The Mary Pearson Award is given yearly to an individual whose contributions advance the hospital's goals of compassion and high standards. (Courtesy of South Nassau Communities Hospital.)

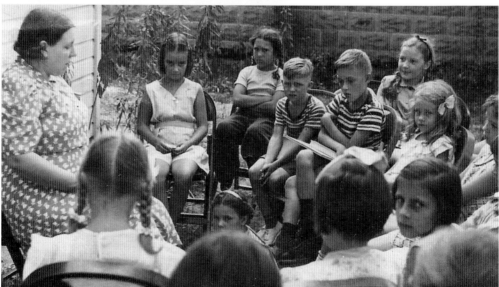

Marion Sager

In 1937, Rufus Smith donated a small building, and Abe Levin donated land by Poole Street for Oceanside's first library. Marion Sager, the first librarian, cataloged all 500 books. On December 6, 1940, ground was broken for a new library on Davison Avenue. Mrs. Oliver Wright, president of the library board, shoveled the ceremonial dirt with Marion Sager looking on. Marion is shown reading during children's outdoor story hour. (Courtesy of Evelyn Rothschild.)

Howie Levy

Oceanside High School 1960 graduate Howie Levy has not forgotten where he came from. His website, http://1960sailors. net/, is simply the greatest and most fun of any website highlighting Oceanside and Oceanside High School. It is chock-full of pictures, trivia, music, and stories about Oceanside people. Howie is a CPA by trade but a sailor for life, and shows genuine interest in his friends from the good old days. (Courtesy of Howie Levy.)

Patricia Roth and Tara Ramos

Tara (right) and Patricia's "sister act" is integral to the community. Pat is a past president, and Tara is the current president of the Kiwanettes, which assists seniors and the needy of Oceanside. These devoted, energetic women are also active in St. Anthony's Parish and Oceanside Community Service. Tara is a member of the Ladies Auxiliary of the Knights of Columbus. Pat has served as president of the Oceanside District Scholarship Committee. She was Citizen of the Year in 2006. (Courtesy of Pat Roth.)

Phil and Bessie Lamonica
The Lamonicas, with Joe Goldberg and Ian McDougall, began Oceanside's youth soccer. United Soccer Club has served children for 40 years. After the death of their son Rudy, Phil and Bessie started a girls' team. They named it Gumbies, Rudy's nickname. Their daughter Donna, with friends, petitioned the board of education for a girls' team. In 1979, Oceanside High School won the Nassau County Championship. Donna scored three goals, and Lisa Krauss scored four. (Courtesy of Donna Lamonica.)

Peter O'Neill
Whether working as president of Oceanside Stallions Football or as an animal rescue volunteer, Pete was a giver. After serving in Korea, he was a volunteer firefighter for 55 years. Forty-eight of those were with Oceanside's Columbia Engine Company No. 1. In later years, he was its historian and photographer, earning the nickname "Scoop" from his buddy Bill Lynch. A devoted family man, Pete cherished his wife, 4 children, and 12 grandchildren. (Courtesy of Frank Januszewski.)

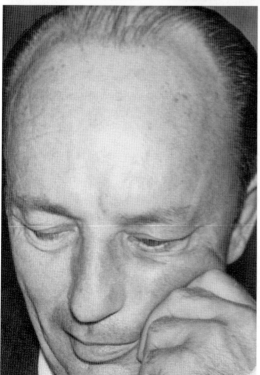

Donald "Buddy" Ackerman

Buddy Ackerman revitalized the Catholic Youth Organization (CYO) Basketball Program in Oceanside, touching the lives of hundreds of kids in the process. Buddy grew up in Rockaway and played for Long Island University, under legendary coach Clair Bee. He played briefly in the American Basketball League and one year with the New York Knicks but felt that starting his landscaping business would be a more secure route for someone who wanted to raise a family. Oceanside was lucky. (Courtesy of Frank Januszewski.)

Sam Cooperman

Sam was known to say that he would never meet a bad youngster. He was a gentleman who put his heart, energy, and money into Oceanside Little League Baseball. In the early 1970s, approximately 1,200 youths were in the program. In his tenure, the number of teams increased from 33 to 70. Sam initiated Sally League Baseball for girls. He loved to quip, "Boys are not eligible." (Courtesy of Michael Limmer.)

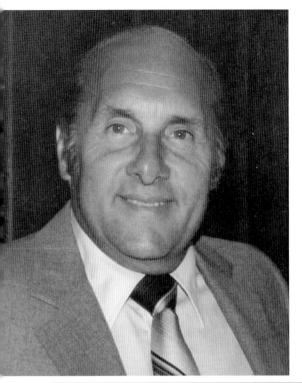

Bill Zener
Bill directed youth basketball for 26 years. His School No. 8 recreation program was a gift to kids. With a saint's patience, he taught fundamentals and sportsmanship. He worked with B'nai B'rith, coached summer basketball at St. Anthony's, and started the first recreation basketball program for girls. A plaque on the Blue and White Building by the high school football field honors his devotion to Oceanside. (Courtesy of Davida Zener.)

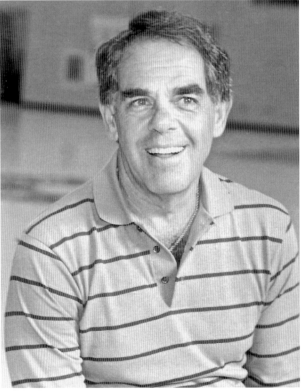

Sam Torgan
Sam made his mark in Oceanside in the areas of recreation, education, and coaching. He was a dearly loved, winning coach and physical education teacher in Oceanside for 36 years. Sam won back-to-back Nassau County Championships in girls' volleyball and was an assistant coach for the 1977 Nassau County Championship football team. His legacy includes promotion and unrelenting support of girls' sports, helping to increase its stature and importance. (Courtesy of Frank Januszewski.)

Rev. Marcus Burr

The First Presbyterian Church of Christian Hook was the cornerstone of the community for many years. In 1844, Maria Pine started a Christian education school with support from neighboring Presbyterian churches. In 1868, Rev. Marcus Burr from Freeport began to hold services at the school. Townsend Southard donated a piece of land, and community members built the church in 1871 on the site it stands on today. Burr was the first pastor and became the superintendent of the school, which was diagonally across from the church. In the church, a stained-glass window of Christ seeking a lost lamb is dedicated to him. Its inscription reads, "To the Glory of God and in grateful remembrance of the devout service from 1871 to 1884 of Reverend Marcus Burr, the founder and first pastor of the church." (Courtesy of the First Presbyterian Church of Oceanside.)

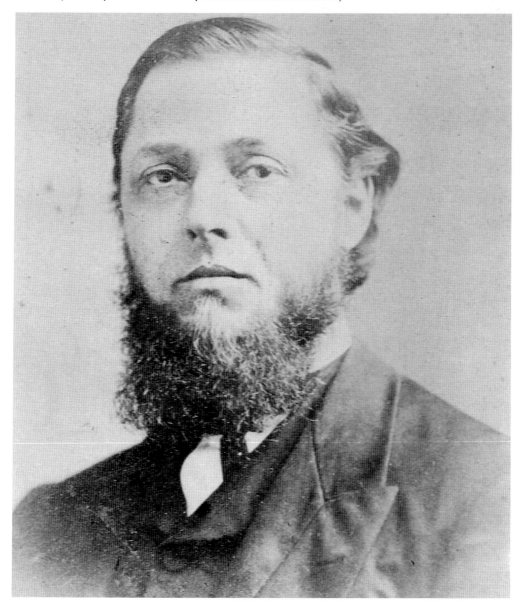

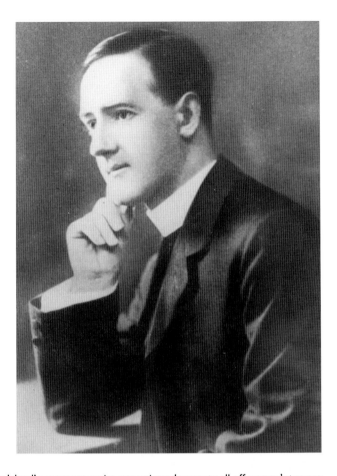

Fr. Robert Barrett

The name of the creator of one of Long Island's greatest tourist attractions does not roll off anyone's tongue these days. Fr. Robert Barrett put Oceanside on the international map and he should be remembered. He was a priest with a dream whose fruition benefited the community and Catholic pilgrims all over the world. His vision, energy, and artistic flair created St. Anthony's Parish. Built on six acres, it was replete with three chapels, meticulously groomed grounds, strutting peacocks, singing canaries, and a three-tiered rose garden. Its crown jewel was the underground church built to resemble the grottoes of Rome. Father Barrett started Oceanside's first Catholic parish in 1927. There were very few Catholics in the Protestant community. His first Mass was in the attic of Salamander Firehouse for 14 people. During the church's construction, he bravely laughed off the antics of the Ku Klux Klan who burned crosses in front of the church. The underground church was adorned with statues, decorative rock formations, colorful lights, shrines, and beautiful artwork procured by Father Barrett from auctions and galleries. The rumor was that he came from the Guinness family of Irish brewery fame, which may have infused him with the upstart capital. Each of the chapels was adorned like the underground shrine. He installed loudspeakers throughout the grounds so that all could listen to Mass, hear the music, and join the singing. He even had a piece of the Blarney Stone in the underground church. Tourist buses would bring 10,000 to 15,000 Catholic pilgrims each weekend. As many as 35,000 worshippers would attend Mass on June 13, the Feast of St. Anthony. Sadly, Father Barrett was transferred to a Brooklyn parish in 1953. St. Anthony's parishioners presented a petition to the Archdiocese of Brooklyn pleading for his return, to no avail. He passed away in 1958. A couple of years later, on March 25, 1960, his underground church went down in flames. Hundreds of people looked on in a state of shock as the blaze raged. Some artifacts were salvaged but many were ruined. It ended an era in Oceanside. (Courtesy of Joan Keefe.)

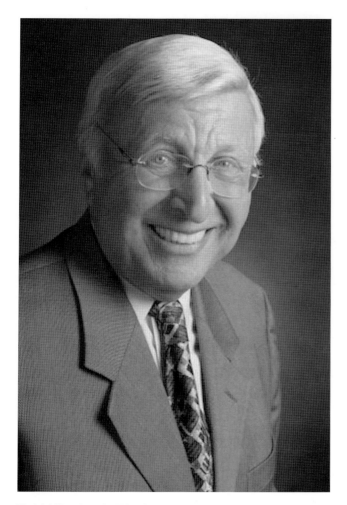

Rabbi Benjamin Blech

Rabbi Blech had a tremendous impact on Oceanside. In the mid-1950s, when some members of Oceanside Jewish Center wished to create an Orthodox congregation, they selected Rabbi Blech as their spiritual leader. The humble beginnings of Young Israel in Oceanside began with a mere 20 families, and services were held above a Chinese laundry on Davison Avenue. Subsequently, the group began to meet at a house on Waukena Avenue. Synagogue was upstairs, and Hebrew school was in the basement. Eventually, its current site, at the corner of Waukena Avenue and Oceanside Road, was chosen. Rabbi Blech helped Young Israel blossom into a dynamic and devoted congregation of 250 families. For 37 years, he faithfully served his congregants. In 1966, he began teaching Talmud at Yeshiva University and continues to teach there today. He believes his friendships in the community motivated him and that he owes a great deal to his experience here. He is the author of 14 books on Judaism and spirituality. He has appeared on the *Oprah Winfrey Show* and is successful worldwide lecturer. His latest book, titled *Death as Intermission*, deals with the Jewish view of death and afterdeath. He is a past president of the National Council of Young Israel Rabbis and has served as scholar-in-residence for many synagogues in the United States and Canada. He was one of three rabbis to personally bestow a blessing on Pope John Paul II after his eminence requested their presence at the Vatican. This act gave hope to Catholics and Jews that they could move forward in reconciliation and love. He serves as a model for all people, regardless of religion. The respect of his students, his scholarly lectures and books, and his caring demeanor are evidence that he is a gift bestowed on the world. (Courtesy of Rabbi Benjamin Blech.)

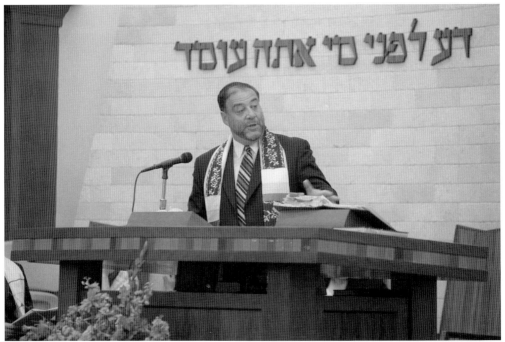

דע לפני מי אתה עומד

Rabbi Uri Goren

Hearing Rabbi Goren sincerely orate at a funeral or seeing him distribute candy to the congregation at a bar mitzvah makes people realize the broad scope of his divinity. He is a man with passion, humor, and spiritual depth. Since 1997, Temple Avodah members have been blessed with his leadership, as has the Oceanside community at large. His personal blessings are his wife, Peppy, and sons, Avi and Gaddi. (Courtesy of Rabbi Uri Goren.)

Frank Vurture

Frank's first calling was baseball, but he then veered toward God, holding meetings with the Christian Young People of Long Island. Ironically, his first church building on Windsor Avenue was once the site of Ku Klux Klan meetings. Frank founded his Windsor Avenue Bible Church with a focus on Bible readings and supporting missionary work. A unique feature of the now defunct church was its Sunday services were broadcast by radio. (Courtesy of Wayne Vurture.)

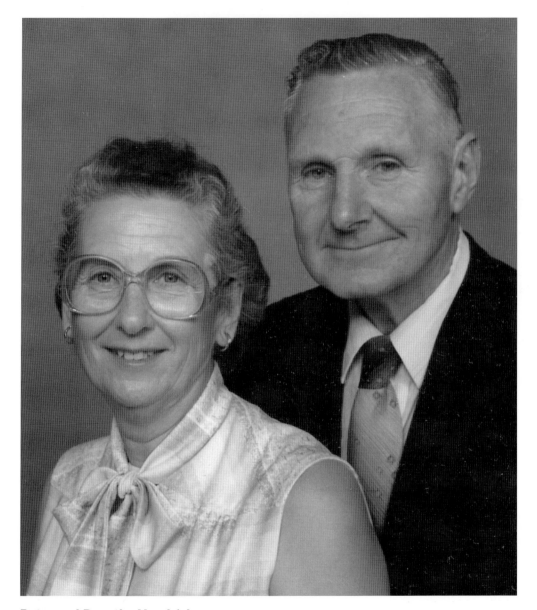

Peter and Dorothy Hendrickson

Dorothy epitomizes the kindness, goodness, and humanity for which others strive. With husband, Peter, who passed away in 2009, she devoted much of her life to the First United Methodist Church, modeling its precepts daily. She taught Sunday school for 35 years, was a volunteer secretary for 30 years, and was a youth group leader for 20 years. Peter was "Mr. Everything": cutting grass, shoveling snow, making repairs, and delivering flowers to the homebound. Together, they assisted at church fairs, delivered food during the holidays, and organized repasts after funerals. Pete is a descendant of the Terrell family and Dorothy of the Pearsall family. Oceanside's Methodist services began in 1895 and the Davison Avenue church was built in 1896. Rev. Janet Porcher has been pastor for the last 18 years, serving her congregation, Oceanside Care Center, the Interfaith Council, and those trying to end substance abuse. Pete and Dorothy were baptized, confirmed, and married there. Dorothy is still an active, respected congregant. Their legacy is one of love. (Courtesy of Linda and Dorothy Hendrickson.)

Minette Gluck

Minette was an original member of Oceanside Jewish Center. The Glucks were one of Oceanside's first Jewish families. Minette served as president of Sisterhood, the women's group that runs events and does charitable work. She and her husband, Samuel, served on the board of trustees. During World War II, she was president of the Nassau County Red Cross. She was a faithful hospital volunteer for 25 years. (Courtesy of Harvey Gluck.)

Robert Moyer

Robert is a longtime member of Oceanside Lutheran Church and past president of the Lutheran Church Council. He has been a member of Salamander Firehouse for 63 years and has 30-plus years with the Kiwanis Club. He has also worked as a devoted and tireless fundraising coordinator for South Nassau Communities Hospital. He is pictured with his wife, Pat, with Ted Ekhardt between them. After 84 years here, Robert still loves Oceanside. (Courtesy of Kaylee Lines.)

Thomas Cook Fetherston

Thomas Fetherston was presidential in character. He was president of the Oceanside Board of Education for 23 years, president of South Nassau Communities Hospital, and president of the New York State School Boards Association. As school board president from the end of the 1930s to the early 1950s, Thomas was recognized for his character and resolve. His son Thomas was a beloved science teacher at Oceanside High School. (Courtesy of Fabian Bachrach.)

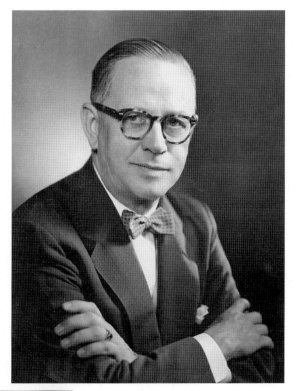

Rev. Henry Sturtevant

Reverend Sturtevant has faithfully served the parishioners of St. Andrew's Episcopal Church for the last 18 years. St. Andrew's began in Oceanside in 1926, and from the mid-1950s to the mid-1990s it maintained a kindergarten-through-12th-grade school. Reverend Sturtevant's other passion is acting. He had a part in the movie *Swoon* (1992) and acts frequently in New York City Theater. (Courtesy of Cyrus Vaseghi.)

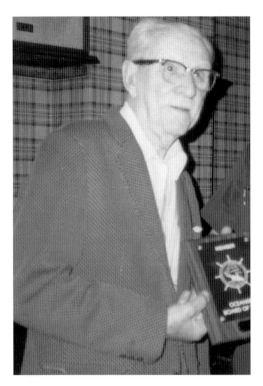

F. Wright "Duke" Donnelly (LEFT)
Duke Donnelly was a man who could get things done when others could not. A World War I veteran, he was a founder of Oceanside's American Legion Post No. 1246. Many of the area's physical and geographical features were improved by his moxie and political savvy. He worked to upgrade canals, roads, and parking. He was a member of the Kiwanis Club and served 19 years as clerk and superintendent of Oceanside Sanitation District No. 7. (Courtesy of Maria Heller.)

Jeff Toback (RIGHT)
Jeff represented western Oceanside for 10 years as legislator of Nassau County's Seventh District. Two of his legislative victories were raising the age to buy cigarettes to 19 and an Environmental Bond Act, which procures, protects, and remediates open space in Nassau County. He is a four-time president of Oceanside Rotary Club, a member of Oceanside Community Service, and former Little League baseball and United Soccer coach. (Courtesy of Maria Heller.)

CHAPTER FIVE

War Heroes

Oceanside has had soldiers in all of the United States' armed conflicts. During the Revolutionary War, most of the community sided with the British because they did not want anyone disturbing the town's peaceful, bucolic existence. Local general Daniel Bedell had people ready for the War of 1812, and Christian Hook soldiers fought during the Civil War. Oceanside's men fought bravely in both world wars and in the Korean War. The names of those who made the supreme sacrifice are on page 81.

Oceanside men and women continue to volunteer, recently fighting in Iraq and Afghanistan. Three who died in those conflicts are remembered in this chapter. A fourth, Sgt. 1st Class Kevin Lipari, died in Afghanistan just as the book went to print. No chapter in any book can do justice to the men and women who are willing to give their lives for the benefit of country and fellow man. An encyclopedia could completely record the events and statistics, but the humanity could never be expressed with pen and paper.

This chapter highlights a few of the soldiers whose courage and sacrifice are representative of all Oceanside's soldiers. Their service is appreciated, and the freedom they have granted the United States with their selfless sacrifices is recognized. Those who have died and those who have fought and returned are owed a thank-you and a salute.

LCpl. Gregory Buckley Jr.

Lance Corporal Buckley chose the path he deemed righteous. Enlisting in the Marines would advance his life in an honorable direction. He wished to be a role model for his brothers, Justin and Shane. On August 10, 2012, he died in Afghanistan. His last letter proclaimed his love for his two brothers and parents, Gregory Sr. and Marina. Brave enough to go to war and soft enough to proclaim his love, that was Greg Buckley. (Courtesy of the Buckley family.)

Sgt. Julian Arechaga, Marines

Marine Corps sergeant Julian Arechaga, an Oceanside High School graduate, gave his life serving his country. He died in Iraq on October 9, 2006, while voluntarily serving his third tour in battle. The members of his unit saw him as a father figure and role model. He was a high school wrestler and after graduation he enlisted and became a member of the 1st Battalion, 6th Marine Charlie Company. (Courtesy of Sheyla Randazzo.)

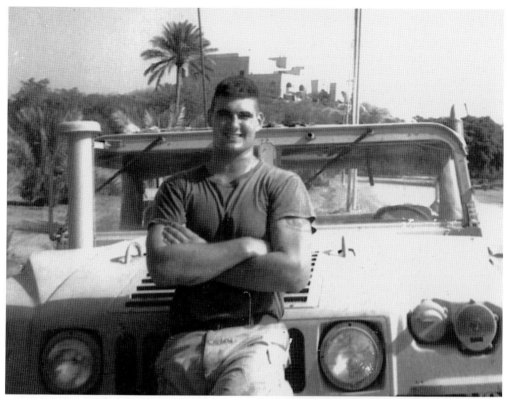

1st Lt. Ronald Winchester, Marines
Ron Winchester will always have a place in the heart of Oceanside. He attended Oceanside schools through middle school before attending Chaminade High School. His mother, Marianna, is a much-loved teacher in the Oceanside District. His sole boyhood dream was to be a Marine. Ron graduated the US Naval Academy, where he starred in football. He died on September 3, 2004, during his second tour in Iraq. Beloved by family and friends, he has made them proud. (Courtesy of Marianna Winchester.)

Sgt. Alexander "Hughie" Jack
Jack flew 12 missions as a tail gunner during World War II before his plane was hit. He lived but was captured and put in a German prison camp. The Allied troops eventually liberated Jack. He was a kicker on the football team at Oceanside High School and is a member of Cortland College's Athletic Hall of Fame. His famous signature greeting for Oceanside alumni was, "Yea, Oceanside!" (Courtesy of MaryJane and Robert Baumann.)

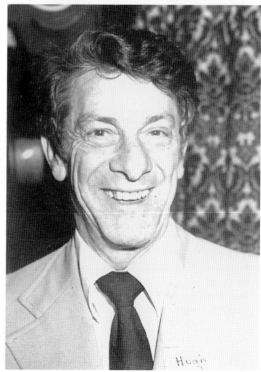

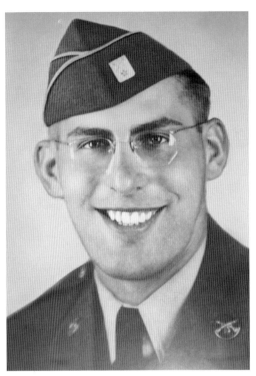

Sgt. John A. Kissell

Sergeant Kissell wrote home in the fall of 1942, enclosing $80 for his mom's birthday present. In another letter to Walter Boardman, he conveyed to the schoolchildren that it would be their job to bring peace to the world after the war. He was the high school valedictorian and Oceanside's first soldier killed in action during World War II. He was posthumously awarded the Silver Star for gallantry in action. Oceanside's VFW post is named in his honor. (Courtesy of John A. Kissell VFW Post.)

Edward Hynes

Ed Hynes, pictured sitting in the middle, found solace in speaking of his war experiences to Oceanside students, helping young people understand the complexity and severity of war. He was a prisoner of war during World War II. He was a soft, caring family man who regularly visited veterans' hospitals and served as chaplain for Oceanside's John A. Kissell VFW Post. He loved his family more than life itself and considered his military friends brothers. (Courtesy of the Hynes family.)

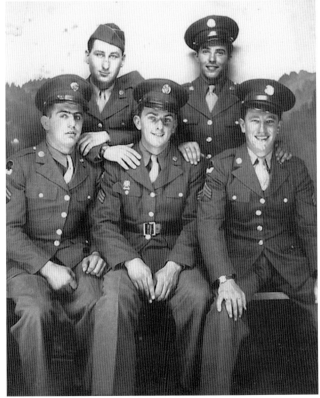

Lt. Daniel K. McMahon, Vietnam Veteran

During 1966, the North Vietnamese attacked Lieutenant McMahon's platoon. Surrounded, the men took hits each time they advanced. Helicopters removed the wounded while others jumped into foxholes. Cross firing ensued until the Viet Cong retreated. For three days, Commander McMahon (left) guided his troops coolly. Numerous times, he retreated to rescue wounded soldiers with no fear for his own life. For his gallantry, he received the Silver Star. (Courtesy of the Associated Press.)

Veterans' Monument

This monument is situated on the front lawn of Oceanside High School. The names of the men from World War II, the Korean War, and the Vietnam War who sacrificed their lives in the name of freedom are etched in stone. They are forever remembered for their selflessness, nobility, and virtue. (Courtesy of Thomas Capone.).

ALWAYS REMEMBERED
THEY MADE THE SUPREME SACRIFICE

WORLD WAR II

HOWARD O. ABRAMS
CHARLES AUBERT
BERTRAM AUDLEY
GUIDO BATTERI
HAROLD BAYLIS
RAY D. BRINEY
RAY BROWER
JOSEPH BUCKLEY
RICHARD A. BURKE
MILTON CHWATSKY
HARRY CORBETT
JOHN DALY Jr
GEORGE S. DEWEY
HARRY R. DIXON
ROBERT DOWLING
HUBBEL A. FELLOWS
WILLIAM R. GRAHAM
ALEXANDER GRANT Jr
EARL K. GRIFFEN
LEWIS H. GRITMAN
EDWARD GROHS
ROBERT HAIG
RICHARD HILL

EDWIN F. HIRSCH
WILBUR T. HORSECRAFT
GENE C. ISAAC
JOHN A. KISSELL
FREDERICK E. KNEIPP
BERT LANG
FRANK P. LANZO
CARL LINDBERG
CARMAN A. MAGISTRO
HUGO A. MAIORANA
GEORGE R. McNAMEE
EDMUND S. MITCHELL
WILLIAM MOUNT
LEON NEAMON
FRANK A. NEU
LENDETH NOON
JAN LIER OKTAVEC
LEWIS E. OLDMIXON Jr
ROBERT RACHOFSKY
EDWIN E. REILLY
ROBERT D. RIDGEWAY
RUSSELL W. ROACH
RALPH SANKIN
GEORGE E. SCHAEFFER

HARRY J. SCHNEIDER
NELSON SPERLING
GEORGE S. STORY
WILLIAM TRENZ
HAROLD TYERS
GEORGE VOGEL
LARRY WILSON

KOREA

RICHARD N. D'ERRICO

VIETNAM

HAROLD J. CANAN
STEPHEN B. CARLIN
DENNIS DeMICHAEL
RUSSELL J. FAUSER Jr
ROY A. GRAHAM
RICHARD A. HUEFFNER
ADAM D. KNECHT
RONALD V. MAIORANA
RAYMOND P. MEEHAN
PETER A. PENFOLD
JOHN M. RIZZO Jr

SFC. Robert Jacoby

Sergeant First Class Jacoby was an Army soldier from 1952 to 1964. He was deployed in Germany during the Korean War and also worked for Army Security. Oceanside Fire Department's ex-chief Jacoby has been a member of Hose Company No. 1 for 57 years. His expertise is civil engineering, but he has also taught firefighter cadets. He was the Town of Hempstead's Veteran of the Year in 2010. (Courtesy of Robert Jacoby.)

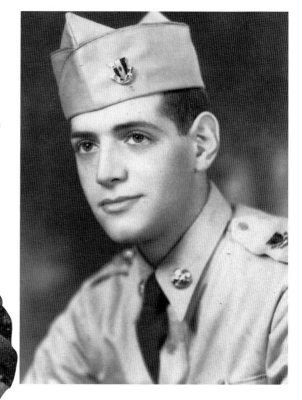

William T. Morris

William Morris was a "one-man war factory" during World War II. He worked 44 hours a week as a postman and 40 in his cellar making wooden spokes for warship steering wheels. He was honored with a ceremony at his Oceanside home in 1942. Two-thousand people watched as maritime, Army, and Navy soldiers saluted and Admiral Vickery presented him the coveted "M" Flag signifying excellence in production during wartime. (Courtesy of Brian Blintis.)

CHAPTER SIX

Sports Legends

Oceanside has come a long way since high school principal S. Taylor Johnson instituted physical education because he felt that vigorous exercise was necessary for the well-being of a student. In 1918, Johnson initiated the first football team, and the part-time physical education teacher—who happened to be a woman—was Oceanside's first football coach.

Oceanside has gone through spurts of success in many different sports. At times through history, Oceanside teams have been dominant. Girls' basketball was a powerhouse in the 1920s. The high school soccer teams dominated Long Island in the 1960s through the 1970s. Track teams in the 1960s and 1970s ran over and through opponents, and the girls' gymnastic teams have won eight county championships since 1986. Baseball had a good run in the beginning of the new century, winning three county, two regional, and one state championship (2000). Oceanside football has given the community much to cheer about, over the last three seasons becoming a top team.

These pages highlight individual athletes who have had national, international, or professional success, along with some of Oceanside's favorite coaches. It should be noted that the high school's Athletic Hall of Fame is one of the finest on Long Island. It was the brainchild of Frank Januszewski (see page 30), and his successors Michael Limmer and Sean Keenan have worked to maintain and modernize it.

Arthur "Art" Heyman

Basketball talent and personality made Arthur, wearing No. 15 in the picture, the greatest Oceanside legend. As a teen prodigy, he would travel to Brooklyn to compete with stars like Connie Hawkins. Locally, he matched up with Long Beach star Larry Brown. Playing for Frank Januszewski, Art led Oceanside High School to the county championship. He was the most sought-after high school player in the country. He was set to play for Frank McGuire at North Carolina, but his stepfather and McGuire had some differences, and so Duke had its new king. At Duke, Art's game flourished, and his reputation as a character grew. He became one of college basketball's greatest scorers, rebounders, and passers. He proclaimed himself the "biggest thing that ever happened at Duke," but sometimes the devil in him would arise. Once, he drove a pretty coed to South Carolina and checked into a hotel, signing the register "Mr. and Mrs. Oscar Robertson." He got caught and was flown back to school by South Carolina's lieutenant governor. Art liked to muse that Southern fans would not believe he was Jewish because of his prowess in basketball. He received letters from the Fellowship of Christian Athletes and an invitation to join the Ku Klux Klan. In 1963, he led Duke to the Final Four and was selected College Player-of-the-Year. He graduated as Duke's all-time leading scorer. No. 25, his number while he played at Duke, hangs from the rafters at Cameron Indoor Stadium. Selected by the Knicks, he was the first pick in the National Basketball Association (NBA) draft. In his first season, he made the All-Rookie Team. Then, his career had some bumps. His playing time and relationship with his coach spiraled downward. One incident involved a card game. When his coach asked in, Art said, "You don't let me play in your game, I won't let you play in mine!" In 1965, he finished his NBA career. Then, he jumped to the ABA, eventually playing for the Pittsburgh Pipers with Connie Hawkins and winning the ABA Championship. He went on to become a successful businessman and restaurateur. He passed away August 27, 2012. Anyone who knew him in later life would say his genteel nature belied his ferocity as an athlete. (Courtesy of Frank Januszewski.)

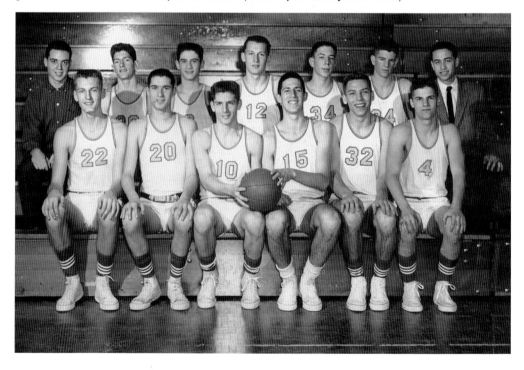

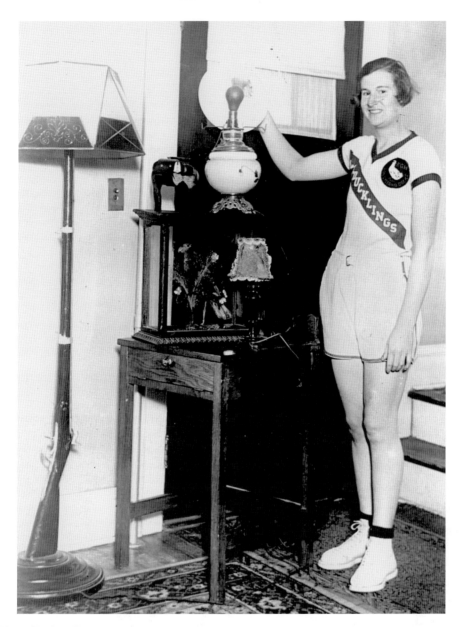

Melissa Pearsall

Renaissance woman Melissa Pearsall is an all-time Oceanside legend. By 1920, women gained the right to vote but she was already doing things men did. She was the sole female at Oceanside High School in shop class. She could change tires and was a superb auto mechanic. She pitched the Oceanside High School girls' baseball team (yes, baseball!) to two consecutive undefeated seasons. As the leading scorer in Nassau County basketball, she and teammate Florence Nau helped the Sailors win four straight conference championships. She played professional basketball for the Long Island Ducklings and professional baseball for the New York Bloomer Girls. The picture shows her wearing her Ducklings uniform and showing off a lamp she made. She also starred for the New York Trevocs softball team in the 1940s. Her adult life was spent as a volunteer softball manager, loving aunt, house painter, and carpenter. She devoted free time to war veterans' causes, fundraising, and volunteering at hospitals. (Courtesy of Keith Pearsall.).

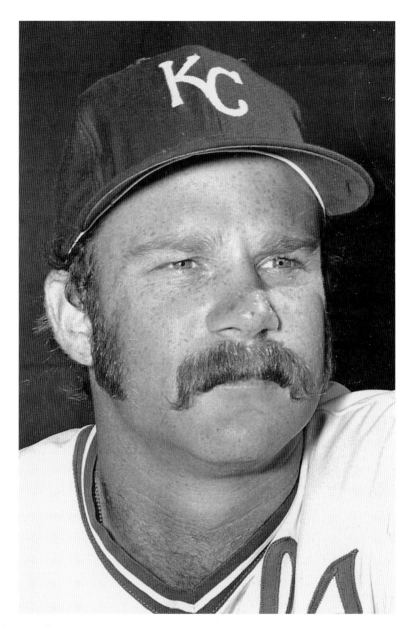

Dennis Leonard
After playing high school baseball in Oceanside for Andrew Scerbo and pitching at Iona College for Gene Roberti, Dennis Leonard became one of major-league baseball's finest pitchers, winning 144 games. From 1975 to 1981, he won more games than anyone. He was a bulldog, pitching numerous innings and complete games. Older Yankees fans remember the four Royals-Yankees divisional pennant battles between 1976 and 1980. In 1980, Dennis, with the Royals, beat the Yankees 3-2 in game two of a Royals' sweep. In the 1980 World Series, he was 1-1, beating Philadelphia in game four. In May 1983, Dennis suffered a crippling knee injury. After four surgeries and years of rehabilitation, he threw a shutout his first game back (April 1986). That season, he was awarded the Hutch Award for best exemplifying competitive desire and fighting spirit. In 1989, he was inducted into the Kansas City Royals Hall of Fame. (Courtesy of Frank Januszewski.)

Jay Fiedler

Jay Fiedler is a man of accolades and modesty. He epitomizes success but remains forever humble. He was one of the greatest athletes in Oceanside history. In high school, he excelled in football, basketball, and track. He left high school with a Nassau County passing record of 4,800 yards and the New York State record for the pentathlon. He then played three years at Dartmouth College, breaking all its passing records. In 1993, he was Ivy League Player of the Year and All-American. After playing sparingly for three NFL teams, he became the starting quarterback of the Miami Dolphins in 2000. At Miami, he led the team to an AFC title in 2001. He passed for almost 12,000 yards in an NFL career shortened by a shoulder injury. Since retirement, Jay has been involved in his football camp, business ventures, and charitable causes. (Both, courtesy of Frank Luisi.)

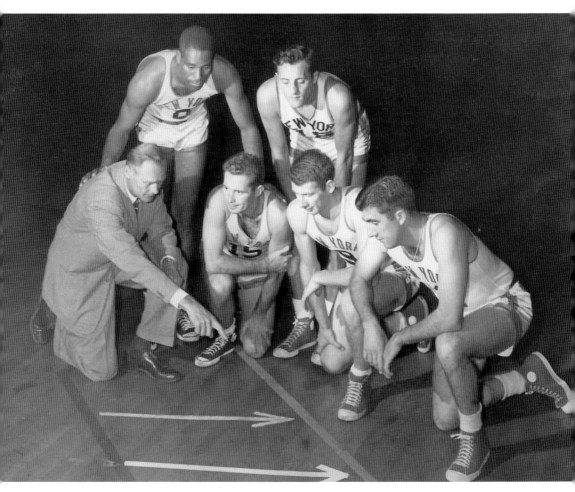

Dr. Ernest "Pal" Vandeweghe

Ernest's lineage contains the Oceanside names Smith, Bedell, and Davison. At Oceanside High School, he starred in football, baseball, and basketball. From 1945 to 1949, he attended Colgate University, becoming a basketball All-American. He played for the New York Knicks while attending Columbia Medical School. The picture shows him (kneeling in the middle) getting a lesson from his New York Knicks coach Joe Lapchick in 1951. Playing in the NBA while attending medical school is one record likely never to be broken. In 1953, he married former Miss America Colleen Hutchins. In his last season, "Ernie Vandeweghe Day" was held at Madison Square Garden, organized by Oceansider Robert Baumann. Ernest was a physician for the US Air Force and the Los Angeles Lakers before starting his private pediatric practice. His children are Shannon, Tauna, Bruk, and Kiki. Tauna was an Olympic swimmer. Kiki starred in the NBA. Tauna's daughter Coco is a professional tennis player. In 1976, Ernest was chairman of the President's Council on Physical Fitness and on the Olympic Sports Commission. (Courtesy of Acme Newspictures.)

John Frascatore

At Oceanside High School, John starred in baseball and basketball, but baseball was his passion. Drafted out of C.W. Post College by the St. Louis Cardinals, he made his big-league debut in 1994. In eight years as a professional, he had an impressive 20-17 record. In 1992, he was 5-2 with a 2.48 ERA for the Toronto Blue Jays. John's passion now is his two children, Gavin and Kaylee. (Courtesy of Andrew Scerbo.)

John Costello

Oceanside High School's John Costello was an All-County pitcher in 1979. In 1982, at Mercyhurst College, Pennsylvania, he led all NCAA schools with an ERA of 1.12 and strikeouts/game at 10.7. In 1988, he was the St. Louis Cardinals' Rookie of the Year. The picture shows him in relief, receiving the ball from Whitey Herzog. Costello finished his professional career with an 11-6 record and 2.97 ERA. He lives in Missouri with his wife, Heather (OHS 1983), and children, Heather and John. (Courtesy of John Costello.)

Rudy Lamonica

Rudy Lamonica was an inspirational, all-star soccer player who led Oceanside to back-to-back Long Island Championships, scoring half the team's goals. At 16, Rudy was stricken with cancer and had his right leg amputated. He managed to carry on courageously, without bitterness or self-pity. Rudy's disposition and sense of humor during his hardship made an everlasting impact on Oceanside. Rudy passed away at age 17, on October 21, 1970. (Courtesy of Bessie Lamonica.)

Nick Polanco

Nick Polanco's tag is "best defenseman in professional lacrosse." At Oceanside High School, he led the team to a county championship in 1996. He was named as a First Team All-American in high school, community college, and at Hofstra University. He won two Junior College National Championships and has played 12 years professionally, eight with the Long Island Lizards. His older brother Armando taught Nick well. Armando also played professionally. (Courtesy of Robert Moltisanti.)

Don Castronovo

Don holds the national high school record for the 180-yard low hurdles. He ran under legendary coach Roy Chernock. In New York State competition, he was undefeated. Don was an All-American at Western Michigan, and his 440-relay team placed third in the NCAA tournament. A teacher at Roslyn schools for 33 years, he also owned Alias Smith and Jones, a popular Oceanside restaurant. It was the place for civic meetings and end-of-year gatherings. (Courtesy of Don Castronovo.)

John Morley

John was a phenomenal wrestler at Oceanside High School, graduating in 1964. That year, he was Most Outstanding Wrestler at the Metropolitan Championships. At Moorhead State University, he placed second in the NCAA Division II National Championships (1969). He wrestled for the New York Athletic Club, winning three national championships. He is in Moorhead State's Hall of Fame and Oceanside's Circle of Pride. The picture shows John carrying the US flag during opening ceremonies at the 1970 World Games. Picked as an alternate in 1972, John is Oceanside's only Olympian. (Courtesy of Frank Januszewski.)

Monica Homer

Before Title IX, Monica showed everyone women could compete. At Oceanside High School, she was in the National Honor Society and played four sports. In 1953, she received the Long Island Girls Association's Gold Key as Nassau County's best female athlete. She continued playing sports at Adelphi University while earning a teaching degree. She became a professor there and eventually chairperson of the Department of Health Studies, Physical Education, and Human Performance Science. Adelphi bestows the Monica Homer Award each year to an outstanding student in the physical education major. (Courtesy of Maria Heller.)

Jill Januszewski Krol

Jill was the first female at Oceanside High School to achieve All-County in three sports. In 1981, she pitched every inning during softball season and set a Nassau County record with 23 wins. She won a county championship in softball and two in volleyball. Her third All-County sport was basketball. In 1983, she was a finalist for the Bruce Gerhke Award for Long Island's Best Female Athlete. (Courtesy of Jerry Januszewski.)

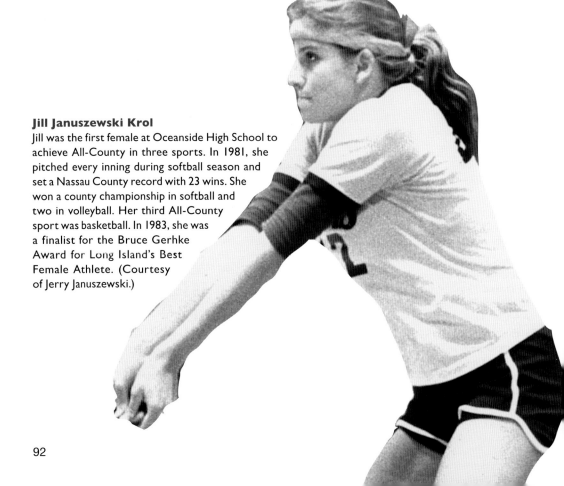

Fred O'Connor

Fred, a 1957 graduate of Oceanside High School, was a member of the football team. He coached briefly at Oceanside High School after playing at East Stroudsburg University, where he won the football team's prestigious Red Shirt Award in 1962. He coached various colleges before his five-year stint as an NFL offensive coach for the Chicago Bears, San Francisco 49ers, and Washington Redskins (1974–1980). He coached Catholic University (1984–1990) and is currently an assistant coach at Florida Atlantic University. (Courtesy of Sean Keenan.)

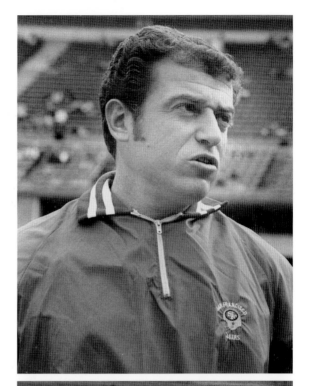

Ron Antanasio

Ronnie "Rat" Antanasio was a lightning-fast and super-skilled All-American for Oceanside High School. His junior year, he scored 33 goals, leading Oceanside to an undefeated season. He starred at Adelphi University, leading the team in assists and winning the NCAA Division II Championship in 1974. He played seven years professionally. His first two were with the New York Cosmos, alongside Pelé. His best season was with the Detroit Express (1981), scoring 6 goals, assisting 9. (Courtesy of Michael Limmer.)

Samantha Cesario

After attending an ice-skating party as a child, Samantha was hooked. During international competition in 2010, she won the Gardena Spring Trophy in the Junior Ladies' Division. In 2011, 18-year-old Samantha won the bronze medal in Poland in the Junior Grand Prix, skating to music from *Black Swan*. She finished eighth in the US National Figure Skating Championships on January 26, 2013. She was in the National Honor Society at Oceanside High School and is an exceptional artist who designs her own costumes. (Courtesy of Jason Manning.)

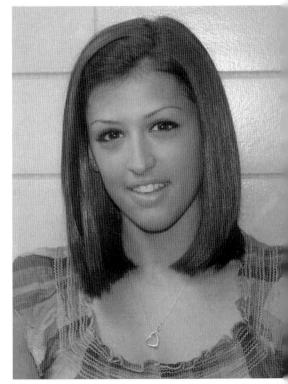

Charlie "Dodge" Hagenmayer

Charlie's wrench was his magic wand. At Pacer's Auto Shop on Lawson Boulevard, with partner George Snizek, he tuned his record-breaking racecar, known as "the Tasmanian Devil." It was a fan favorite and one of the fastest, most beautiful in drag racing. In the 1960s, test runs took place on Lawson with cheering fans. Police closed off the street. Dodge posthumously entered the East Coast Drag Times Hall of Fame in 2008. (Courtesy of Nancy Lopez.)

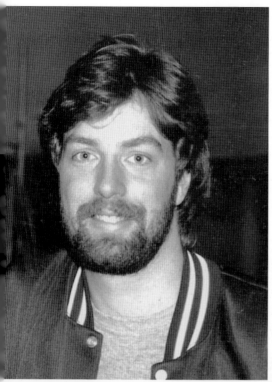

Andy Morris

Born in North Bellmore, Andy is Oceanside's adopted son. A premier educator and spirited Sailor, he is the go-to-guy to rally support and raise funds whenever he sees a humane cause. One of Oceanside's most successful coaches, he won eight county championships in girls' gymnastics and three in baseball. In 2000, he was selected New York State Coach of the Year when his baseball team won the high school's only state championship. (Courtesy of Michael Limmer.)

Andrew Scerbo

Andrew Scerbo was an esteemed teacher and baseball coach at Oceanside High School. He attended Mepham High School and then Ithaca College, where he captained the baseball team. He began teaching in Oceanside in 1963 after a short stint in the minor leagues. His knowledge, motivating skills, and teaching aptitude always had his baseball teams prepared. They won 12 league titles. He is pictured below (left) with Richard Woods. Andrew mentored nine future professionals, including three major leaguers. (Author's collection.)

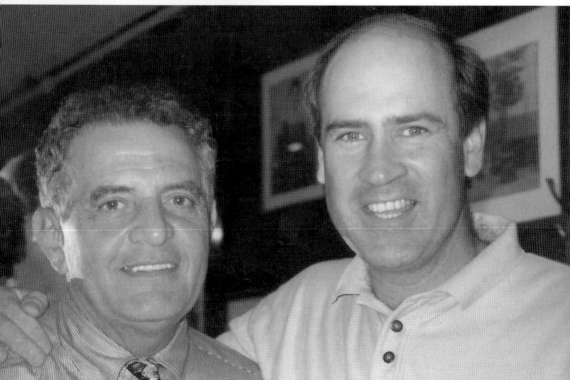

Patricia Hanlon Smith
Patricia was a charter member of Oceanside's Circle of Pride. The Circle of Pride recognizes the greatest athletes, coaches, and community members in Oceanside High School. Patricia was the Nassau County All-Around Gymnastics Champion her senior year in 1972. She attended one of the best women's gymnastic schools in the country, Southern Illinois University. In 1976, she received All-American honors at the Association for Intercollegiate Athletics for Women Gymnastics Championships. (Courtesy of Frank Januszewski.)

Marianna Winchester
Marianna started as a physical education teacher at Boardman Junior High School in 1969. She initiated the district's first junior high school volleyball and gymnastic teams for girls. In 1989, she began coaching the high school girls' varsity soccer team. She has taken them to eight county championship games. She has been recognized as Coach of the Year, and her teams have won the Sportsmanship Award multiple times. (Courtesy of Michael Limmer.)

CHAPTER SEVEN

Entertainers

These pages are filled those who make people laugh, cry, smile, and feel good inside. Their works provide diversions. The Oceanside people in this chapter are actors, dancers, cartoonists, writers, musicians, directors, clowns, and singers. Some should be familiar. People roared at the sitcom *Moonlighting* and now may be addicted to *American Idol*. *The Five-Year Engagement* brought many to theaters last summer, and everyone loves solving crimes with the cast of *Numb3rs*. *Goodfellas* left a lasting impression, and millions have purchased Jack LaLanne's Power Juicer. In this chapter, one will see they all have an Oceanside connection. Many of these entertainers have been Oceanside High School thespians or part of the district's art and music programs. Others carved their own paths.

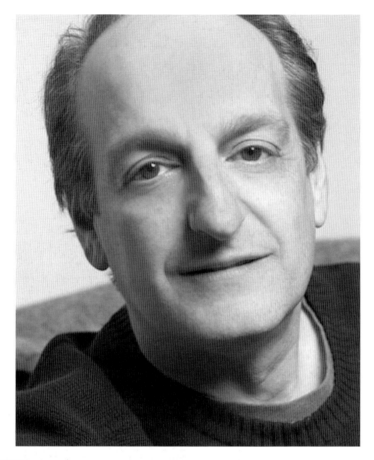

David Paymer

David Paymer loved Oceanside. He describes it as "a great place to grow up . . . an All-American, middle-class community with beautiful beaches nearby." His parents wanted him to be a doctor, but it was their interest and his brother Stephen's interest in theater that sparked David's. Stephen starred in high school productions, and his parents did local theater, writing, directing, scoring, and starring in hometown musicals like *Oceanside USA!* In high school, David's major influence was drama coach Barry Kaplan. Barry worked his players for long hours with the artistry of a master. Before each show, the cast would make a circle, hold hands, and he would say, "Go out there and make magic happen!" At the University of Michigan, David continued performing. After graduating, he answered an open call for *Grease* with the National Touring Company, landing the part of Sonny. He then starred on Broadway in this same role, with Oceansider Sandy Zeeman. His first movie was *The In-Laws*, but much of his early work was in television. He lived in California with his brother, who was writing for shows including *Roseanne* and *Mad About You*. In 1990, David auditioned for the Billy Crystal film *City Slickers*. Billy and he became fast friends. Crystal wrote *Mr. Saturday Night* with Paymer in mind for the role of Stan Yankleman. This part moved him from "the most reliable character actor in Hollywood" to the big time. For his outstanding portrayal, he was nominated for a Golden Globe and an Oscar. He has appeared in over 70 feature films, including *Payback*, *The American President*, *Amistad*, *Get Shorty*, *Quiz Show*, and *Oceans 13*. He has appeared in over 100 television shows and directed numerous episodes for television series, including *Grey's Anatomy*, *Brothers and Sisters*, and *Medium*. Acting is still a passion. He recently played Jason Segel's father in *The Five-Year Engagement*. He may be the greatest character actor of his time; however, through it all, he has remained humble and, in his words, has "never forgotten Oceanside." He lives in California with his wife, Liz, and their two daughters, Emily and Julia. (Courtesy of Larissa Underwood.)

Ken Werner
"Perfection . . . 360 degrees of soul and science in one human being." Quincy Jones's quote says what many feel. Kenny Werner is regarded as the best jazz pianist in the world. He grew up studying classical piano, but the spirit of improvisation consumed him. He was a prodigy, appearing on television and recording his first record when he was 11. He studied at Berklee School of Music and learned from the world's greatest musicians. He has toured internationally and recorded over 25 CDs of original music. For the last 20 years, he has played and arranged for Broadway superstar Betty Buckley. He received a Grammy nomination in 2003 for his instrumental composition *Inspiration*. His book, *Effortless Mastery: Liberating the Master Musician Within*, is a standard read for new musicians. His last CD, *No Beginning No End*, earned him a Guggenheim Fellowship Award in 2010. (Courtesy of Ken Werner.)

Ed Wexler

Ed Wexler's caricatures and illustrations in periodicals like *US News & World Report* and the *Hollywood Reporter* (see cover on facing page) give cause to giggle and awe. He has an exceptional ability to draw a caricature, make a statement, and make people smile. After graduating as an illustration major from Cooper Union in 1977, he has worked both independently and for Disney. He was an animator on Ralph Bakshi's *Lord of the Rings* and numerous commercials and television specials over the years. Anyone who laughed at bugs screaming, "RAAAAID!"; or got the munchies from Keebler Elves; or smiled while enjoying breakfast with Sugar Bear, Tony the Tiger, or Snap, Crackle and Pop can thank Ed. He illustrated many Academy and Emmy Awards covers for the *Hollywood Reporter*, which has earned him an international following. He loved Oceanside and the high school. He recalls caring teachers with doors open, always willing to listen. He remembers social studies teacher Mr. Sullivan complimenting him for his note-taking during class one day. Ed had spent the entire period doing a caricature of Sullivan. His drawings can been seen regularly on the Washington Whispers page in *US News & World Report*. Ed was nominated for an Emmy Award for directing *Genie's Great Minds*, a series of 90-second animated spots for Disney, featuring Robin Williams as the voice of Genie, which ran Saturday mornings on ABC. The Genie spots helped teach kids to think for themselves. He's currently designing characters for Disney's *Jake and the Neverland Pirates*, a top-rated preschool show on the Disney Channel. (Both, courtesy of Ed Wexler.)

THE Hollywood REPORTER®

a Nielsen Business Media publication 78th year

September 14-16, 2007

Illustration:
Ed Wexler

INTERNATIONAL WEEKEND EDITION

$5.99 (U.S.) $8.99 (Canada) £5.50 (U.K.) € 9.25 (EU)

59TH

EMMY
AWARDS
SPECIAL
PREVIEW
ISSUE

Diane Farr

Diane Farr's resume is voluminous—writer, producer, director, and actress. At 11, she rode the LIRR from Oceanside to New York City for modeling auditions. She earned a theater degree, attending colleges in London and New York. While doing theater in New York, she assumed ownership of a bar. Selling it enabled her to finance living in California to concentrate on her career. MTV's dating advice show, *Loveline*, provided Diane recognition. Then a role in *Arli$$* led to critical acclaim and consistent work in shows like *The Drew Carey Show* and *Roswell*. Her star shone in *The Job* and *Rescue Me*, with Dennis Leary, and *Numb3rs*. Her life now includes three children. She has written two books, *The Girl Code* and *Kissing Outside the Lines*. The latter examines the tribulations of biracial marriages, including hers to her husband, Seung Chung. (Courtesy of LauraKate Jones.)

Philip J. Lang

The kid from Locust Avenue in Oceanside who played trombone in the Oceanside High School band became one the all-time greats in American music. After graduation in 1929, he attended Patrick Conway's Military Band School, which later became part of Ithaca College. He then studied at Columbia and Julliard. During World War II, he conducted the US Marine Maritime Band. The picture above shows him leading it down Broadway in 1944. In 1945, he orchestrated his first musical, *Billion Dollar Baby*. The following year, Irving Berlin hired him to orchestrate *Annie Get Your Gun*. That box office smash set his reputation in stone. Fifty-six Broadway musicals followed, such as *Hello, Dolly!*, *Mame*, and *My Fair Lady*. He also wrote scores for the Boston Pops and Radio City Music Hall. Throughout his success, Phil was approachable, kind, and kept his sense of humor. (Courtesy of Michael Boss via the late Ruth Lang's collection.)

Glenn Gordon Caron

Glenn's peers at Oceanside High School were lucky to have seen him in *Guys and Dolls* (right). Since high school, many other people have had the opportunity to enjoy his creative brilliance. After majoring in drama at SUNY Geneseo, he worked in an advertising agency and wrote screenplays in his spare time. Notable executives saw his talent, which led him to television. He wrote for *Taxi* and *Remington Steele*. Eventually, ABC asked him to create and write a pilot for a boy-girl detective show. He hated the premise, so he lampooned it. The result was the innovative and creatively written smash *Moonlighting* (1985–1989), with Cybill Shepherd and Bruce Willis. It was nominated for 16 Emmys its first year. (Incidentally, Willis's receptionist was Oceansider Allyce Beasley, aka Alice Tannenberg.) Caron's next big hit was *Medium* (2005–2011), which won an Emmy for Patricia Arquette in 2005. He continues to work as a producer, director, writer, and creator. (Courtesy of the Oceanside School District Archives.)

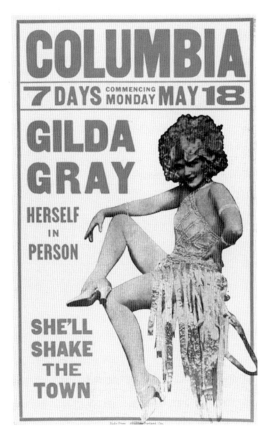

Gilda Gray

Every American literature student eventually reads the name of this famous Oceanside resident from the 1920s. In *The Great Gatsby*, during a party, a woman who dances is believed to be the "understudy of Gilda Gray." She was a Polish immigrant who began by singing in the saloons of Milwaukee. She became an international success in the Ziegfeld Follies, setting records for attendance at her shows. At one point, her salary was $20,000 a week. She loved her house in Oceanside. She spent weekends and summers there. It had tennis courts, locust trees, and on her property she had eight guesthouses. Gray was no recluse. She could be seen toiling in her vegetable garden, shopping in town, and attending charitable events. She would even "shake it" every once and awhile. Her house is now Towers Funeral Home. (Courtesy of Bill Shelley.)

Edmund Tester

Edmund was a 1945 Oceanside High School graduate. His snappy clothes led to the moniker "Jazzy Boy," which later morphed into "Jazzbo." After serving in the Army, he became Long Island's first full-time clown. He was a focal point of Oceanside's Memorial Day Parade, driving his Ford Model A jalopy. After Nathan's opened, Kiddieland Park became JazzboLand, which Edmund operated. "I left my audience laughing. I was happy. I loved Oceanside," said Tester. (Courtesy of Edmund Tester.)

Gregory Mitchell
One of Broadway's greatest dancers and a contemporary of Mikhail Baryshnikov was Gregory Mitchell. After graduating the Juilliard School in Manhattan in 1973, he starred in many Broadway shows, including *Man of La Mancha* and *Chicago*. He also acted in television and films. He was a forceful stage presence and the winner of two Gypsy Robe Awards, given to Broadway singers and dancers. Gregory passed away in 2004. (Courtesy of the Oceanside School District Archives.)

Jackie Tohn
Jackie's desire to perform was fueled by her witty mom and singer-songwriter dad. At 12, she starred in television's *The Nanny*. She sparkled in the Off-Broadway comedy *Jewtopia* and was a semifinalist on *American Idol* (season eight). In 2011, she competed on Bravo's *Platinum Hit*. Her song "What is Love," heard in the Disney movie *You Again*, won Best Music Video at the 2010 Hollywood Music in Media Awards. (Courtesy of Stephen Busken.)

105

Forbes Riley

Passionate and energetic describe Forbes. After winning Miss Teenage New York while still at Oceanside High School, she went fast-forward into a world of plays and films. Currently, she is called the best infomercial host in the world. A member of the National Fitness Hall of Fame, her newest workout product is Spin Gym. Self-made success and a charitable nature make her a role model to all young women. (Courtesy of Forbes Riley.)

Frank Pellegrino

In the 1960s, on the southwest corner of Anchor Avenue and Lawson Boulevard was Archie's. It was a candy/soda/cigarette store, serving mostly people getting on and off the train. The store owner was Pellegrino's dad (also named Frank). Frank worked at the store but he had other dreams. The Frank Pellegrino that the world knows is the co-owner of Rao's who also has an acting resume. He graduated Oceanside High School in 1962. He has appeared in numerous television shows and movies. He played Johnny Dio in *Goodfellas* and FBI chief Frank Cubitoso on *The Sopranos*. His restaurant Rao's is unique and well known. It is located in East Harlem, New York City. Frank has written three cookbooks including *Rao's Recipes from the Neighborhood*. Frank sang at Rao's in the 1970s and will still croon once in a while to the delight of customers. (Courtesy of the Oceanside School District Archives.)

CHAPTER EIGHT

Fearless Firefighters

For more than a century, the Oceanside Fire Department has been a sustaining component of the community. It is comprised of men and women who volunteer to respond to fellow citizens in grave situations—often putting their own lives in danger. Oceanside admires and respects them.

This chapter highlights a few. Others are spotted throughout the book because firefighters are civic-minded and care about the totality of the community. Historically, Oceanside's firefighters have shared their firehouses for religious services and civic meetings. They are ubiquitous in the community and are always ready to hoist flags, put up holiday lights, talk to schoolchildren, volunteer at charity events, and spruce up parades. They especially showed their mettle during Superstorm Sandy in the fall of 2012. Not all the firefighters in this chapter are part of the Oceanside Fire Department. The chapter recognizes those firefighters from Oceanside who died on 9-11 and iconic firefighter Bob Beckwith.

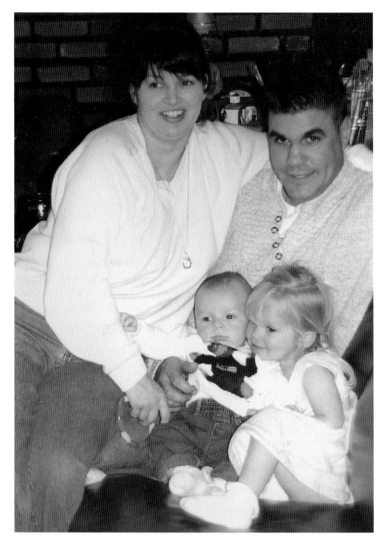

Kenneth Marino

Kenneth Marino's job was to save the lives of others. He is a veritable hero to his wife, children, and to many others. In his youth, his desire to be a firefighter led him to volunteer at Oceanside Hose Company No. 1. On the morning of September 11, 2001, before he responded with New York City Rescue Company No. 1 to the World Trade Center, he played with his children Kristin and Tyler at his firehouse. He sat them in the truck and held Kristin on his lap. At the end of the visit, he kissed and hugged his children and wife, Katrina. He was a model father and husband. His life was his family. He worked many odd jobs just so they could have the things they needed. He had a zest for life, a love for watching hockey and baseball, and enjoyed playing Strat-O-Matic Baseball, his hobby. He loved sports. He played men's softball and was a star of the track-and-field team at Oceanside High School. In his honor, two scholarships are awarded annually at Oceanside High School in his name. One is for a deserving member of the track team and one for a person whose parent is a firefighter. His favorite baseball player was Ken Griffey Jr. After 9-11, Marino's wife sent Griffey Jr. an e-mail, asking him to hit a home run for her husband. The day he received it, he hit one in the fourth inning. Katrina was thrilled. Griffey Jr. said, "It doesn't matter what I do on the baseball field. This man gave his life saving others." Greater love hath no man . . . (Courtesy of the Marino family.)

Thomas Gardner

"When he walked into a room, everyone's eyes would light up and their worries would go away." These are the sentiments of Amy Gardner for her father, Thomas, who died responding to the World Trade Center on September 11, 2001. Thomas worked initially as a New York City firefighter for Engine Company No. 59 in Harlem and, at the time of the 9-11 tragedy, at Hazardous Materials Company No. 1 in Maspeth, Queens. He specialized in toxic threats and traveled across the country giving seminars to law enforcement agencies. He lived life with gusto. His hobbies were numerous, yet his family consumed his life. He was a lover of animals who worked for Volunteers for Wildlife, a nonprofit conservation and education organization on Long Island. He was a hockey enthusiast who enjoyed playing alongside good friends and his brother Joseph. The picture shows him after a hockey game with his two children, Christopher and Amy. He had a great sense of humor. He wrote and sold jokes to likes of Phyllis Diller, Joan Rivers, and Henny Youngman and he worked a comedy routine on WGBB radio with a fellow firefighter from his company. During his time as a firefighter, he earned a degree in biology and education, graduating Queens College with honors. He planned to become a science teacher as a second career. His love for the outdoors rubbed off on his family, whom he taught to canoe, hike, and appreciate nature. To his wife, Liz, he was a devoted, loving husband and a person who always made time to help people with their problems. His example of superior courage, exuberant spirit, and strength of character is the greatest gift Christopher and Amy will ever receive. (Courtesy of Amy Gardner.)

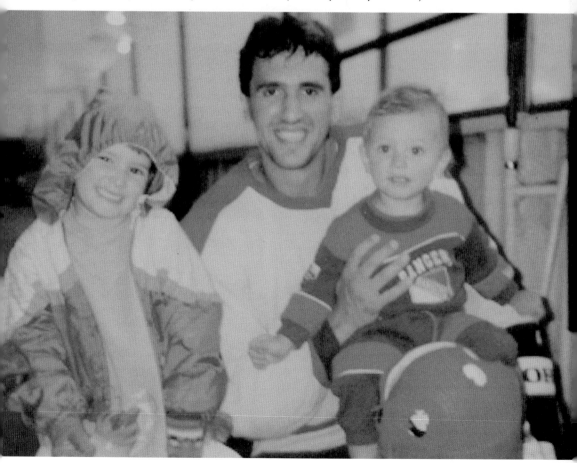

John Florio

John was 33 years old when he responded with Engine Company No. 214/Ladder No. 111 of Bedford-Stuyvesant, Brooklyn, to the World Trade Center on September 11, 2001. Like many remarkable people, John lived an active life. He was a workout enthusiast, Little League coach, and big-time Metallica fan. He graduated from St. Francis Preparatory School in Fresh Meadows, Queens, in 1985. He then attended Nassau Community College before taking the fire department test. He loved his job as a firemen, and according to his wife, Shari, "He always went to work with a smile." He was a loving husband, devoted father to Michael and Kylie, and a loyal friend who enjoyed the camaraderie of his firefighter brothers. At John's funeral, "Nothing Else Matters" by Metallica was played, and a heartfelt letter written by James Hetfield, Metallica's lead singer, was read. (Courtesy of Shari Goldman Florio.)

Robert Spear Jr. (LEFT)

Robert had finished his shift on the morning of September 11. He was dressed in civilian clothes and ready to go home when the alarm sounded at Engine Company No. 26, Manhattan. Without hesitation, he changed back into gear and was off. His mindset was service to country and people. He was a noble spirit who ran toward danger to help others because it was his duty. He joined the Army when he was only 19. He left after he met his future wife, Lorraine. His sense of duty contradicted his humorous side. He loved to laugh, not caring if the joke was on him. He would do anything for anybody. As tough as he was, he did not shy from playing dolls with his nieces, whom he took to see the Backstreet Boys two days before the alarm rang. (Courtesy of Irene DeSantis.)

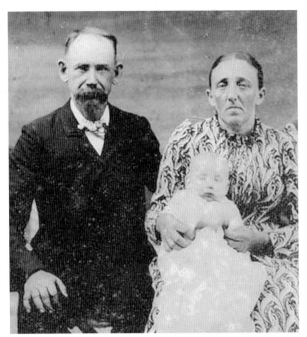

Thomas Titus Ramsden

Thomas was a founding member of Salamander Hook, Ladder and Bucket Company (1902). The first organizational meeting occurred at his home. Thomas, seen in the picture with wife, Emily, and son Wright, became the department's first treasurer. He was later ousted when some members became unhappy with his work. When the new treasurer took over, he realized that Salamander was indebted to Ramsden. Thomas was carrying the department out of his own pocket. He immediately resigned. The job was Ramsden's again. (Courtesy of Marian Wagner.)

Nicole Bettes

Nicole is from a family of firefighters and followed their tradition. She is the only female firefighter in the Oceanside Fire Department. Her admirable achievement was realized with no double standard. Nicole has 12 firefighting relatives including her father Robert (ex-chief), cousin Thomas Bettes Jr. (chief), David Bettes, and Sean and Tim Costigan (all ex-captains). Her uncle Thomas Bettes Sr., ex-chief and Oceanside Citizen of the Year, passed away in 2003. (Courtesy of the Bettes family.)

Lenny Giebfried

Lenny (pictured) and his twin brother, Kenny, began as Oceanside Fire Department volunteers in 1957. The brothers served in Rescue/EMS and played in the fire department band. Lenny worked his way up through the ranks, becoming chief of the department in 1976. Under his leadership, Oceanside placed first in every parade competition. Kenny was captain of the band and band chairman. Lenny passed away in 2010, and Kenny is still an active volunteer. (Courtesy of Bill Lynch.)

Craig DeBaun

Craig is an ex-captain of Hose Company No. 1 and the longest-serving commissioner in Oceanside Fire Department history (31 years). He has served 40 years as a firefighter, 40 years as a Kiwanian, and 40 years in the Knights of Columbus. He is a past president of the Oceanside Republican Club and served on the board of directors of South Nassau Hospital. In 1997, he was Oceanside's Citizen of the Year. (Courtesy of Craig DeBaun.)

Sean and Bill Lynch

The brothers Lynch each served two years as chief of Columbia Engine Company No. 1 in Oceanside. Bill (right) was Oceanside Fire commissioner from 1999 to 2007 and works for Nassau County's Sherriff's Office. He is also a member of the International Longshoremen's Association. Sean is a career firefighter with the Fire Department of New York, Engine Company No. 210 in Fort Greene, Brooklyn. Bill has been with Columbia 35 years and Sean for 21 years. (Courtesy of Bill Lynch.)

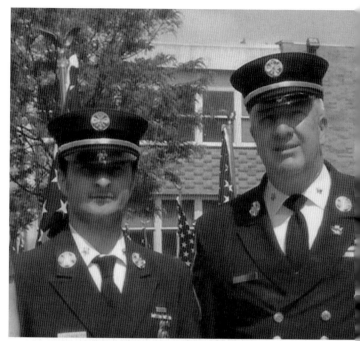

Thomas Staab

Chief Thomas Staab from Columbia Engine Company No. 1 was the first Oceanside Fire Department firefighter who made the supreme sacrifice, on December 7, 1958. Others who gave their lives in the line of duty are Capt. Vincent "Bink" Herbert, Anthony Zito, Capt. William Koerner, Stephen Wade, Chief Dominick "Bubba" Lagudi, and Capt. Joseph D. Jarvis Sr. (Courtesy of Bill Lynch.)

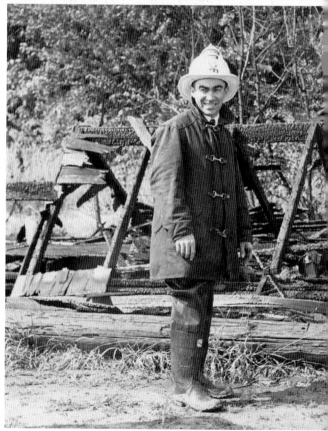

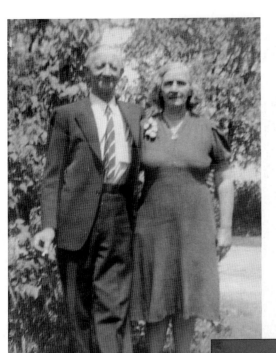

Linus Anderson

Linus, pictured with wife, Ivy, was a founding member of South Side Hose Company No. 2. John Denis organized the firehouse in 1927, and the initial meeting was at Anderson's house. South Side's first truck, a Ford Model T, was kept in his garage. He was a carpenter, drove an oil truck, and owned a store that sold soda, candy, and cigarettes on Mott Street. He rang the fire bell by hand. (Courtesy of Joan Ivarson.)

John Wettach Goerlitz

John was a member of Salamander Company, joining in 1929. In his 40 years with the Oceanside Fire Department, he enjoyed the camaraderie and goodwill as much as anyone. With his fellow firemen, he played polo behind the firehouse, played semiprofessional football, played cards, and attended horse races. The Oceanside Fire Department was the center of his life. He, like most firefighters, attained a fraternal brotherhood known by very few. (Courtesy of Carol Croce.)

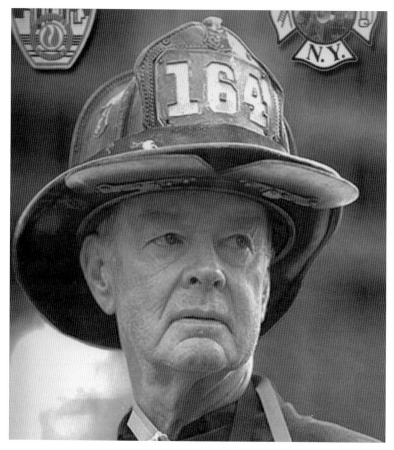

Bob Beckwith

Whether firefighters are born heroes or learn it on the job, eventually it becomes their second nature. When the country was attacked on 9-11, Bob Beckwith, a 69-year-old retired fireman, answered the call as if he were a rookie. He responded for his country and brother firefighters. Three days later, he became an American icon. At Ground Zero, he was standing atop a crushed fire truck. A man whom he believed to be a Secret Service agent gave him instructions. He was to help to the top of the rubble the next man who walked by, then jump down. The man he pulled up was Pres. George W. Bush. When Bob started to jump down, the president said, "Hey, where are you going? You're staying here with me!" With his arm around firefighter Beckwith, the president rallied the spirits of Ground Zero workers with an uplifting speech. Together, they projected an image of hope as Bush waved a small US flag. The picture of the two became a sensation. It appeared on the cover of *Time* magazine. It was a vision to which Americans clung. It gave optimism. Bob's years as a fireman never could have prepared him for what was next. All media sought after him for interviews. In telling his story, he assumed the role of healing ambassador throughout the country and the world. This humble, soft-spoken man transformed himself into a captivating public speaker. Bob is personified goodness. The thousands of dollars he receives for speaking engagements, he donates to the New York Firefighters Burn Center Foundation. He and his wife, Barbara, also volunteer their time at this foundation. He is a Baldwin resident within the Oceanside School District. All six of his children were Oceanside High School graduates. He still projects hope. He is quick to say he sees so much good in people, that so many have their hands out, ready to help. He says he is a celebrity for the wrong reason. However, in a time of need, the American people could not have asked for a more perfect representation of what Americans stand for. God bless Bob Beckwith. (Courtesy of the Beckwith family.)

CHAPTER NINE

Business People

"Shop with Pride in Oceanside" is the slogan of the chamber of commerce. Residents only have to travel minutes to obtain virtually everything they need. Oceanside merchants provide jobs, products, capital, services, and recreation. The business people mentioned in this chapter have made a significant impact. Their businesses are either memorable or longtime favorites. They and others mentioned previously are by no means the only business people who have influenced the area.

Locals will always remember Mel's Stationery Store at Lincoln Shopping Center. Mel had everything, even if it took him a few minutes to find it. Whistle Stop Bake Shop has been satisfying locals' sweet teeth for almost a half century, while Franklin Petroleum has been keeping people toasty since the days of coal. Blossom Heath Flowers supplies flowers for the prom, and Elite Cleaners cleans food stains off tuxedos the next morning. Money that once gained interest at Fred Shaw's Oceanside National Bank now grows at Joe Garay's Oceanside Christopher Federal Credit Union. Lou, Dom, Jack, Mike, and Nicky have cut men's hair over the years while Rita coiffed, permed, and styled women's hair. Whitbread Lumber takes people back in time, but not as far as Messler's Hardware previously did. Frank's Taxi gives rides while people's cars are at Danny's Auto Repair, Oceanside Wheel Alignment, or getting straightened out at Island Auto Body.

After finishing this last chapter, each Oceansider should go to Busco's Deli for a salad. Then he can head over to "The Triangle" and buy some salami at Pastosa Ravioli. Be careful of the rabid dogs near Dr. Gower's Animal Hospital because rooms at Vanella's Funeral Home await. He should ride his Oceanside Cycle home, walk with his Incredible Feets on his Oceanville Mason Supply walkway to his Hal Knopf–purchased, Frank J. Ott & Sons–remodeled home (with Contractor's Express lumber). Then, he can watch the television he bought at Home Appliance and say a prayer his children don't have to go to the Fairy Lice Mothers. (P.S.: Don't copy this paragraph at Publicity Plus/PIP Printers. That's illegal.)

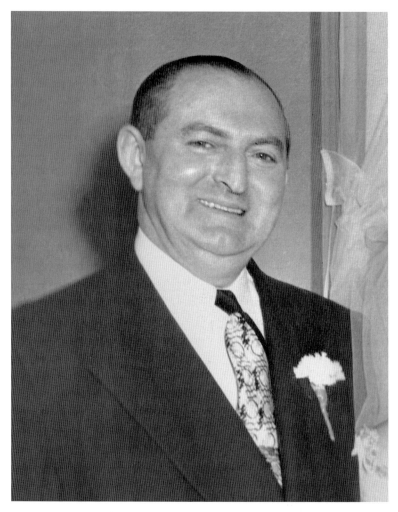

Leon Shor

Leon Shor, with his brother-in-law Murray Hadfield, opened up the Roadside Rest, a little fruit-and-vegetable stand, on the side of unpaved Long Beach Road in 1921. Presuming that people would be hungrier on the way home from Long Beach than going there, they opened up on the road's east side. They eventually added a grill for hot dogs and spigots for drinks. Business boomed. Each year, they used their profits to increase the size of their restaurant. By the end of the 1920s, they had built a large building with beautiful Spanish-style architecture. It developed into, along with St. Anthony's underground church, the most popular location ever in Oceanside. In the 1930s and 1940s, the Roadside Rest had some of the great names in big band music like Eddie Duchin, Ted Wilson, and Ozzie Nelson. People would dance the night away under the stars. From 11:30 to midnight, the music was broadcast coast-to-coast by the Mutual Broadcasting Company. The national exposure made the restaurant even more popular. It was not just Brooklyners and locals patronizing but anyone visiting in the tristate area. Shor and Hadfield opened another Roadside Rest in Merrick and one in Miami. Leon's good fortune continued when his friend Robert Moses asked him to take over the concessions at Jones Beach. Then came World War II and gas rationing. People were no longer driving, and at times, Long Beach Road was barricaded. The war brought an end to one of Oceanside's great businesses. Hadfield and Shor parted ways. Leon got back on his feet years later and opened up five restaurants on Long Island, aptly named Shor's. (Courtesy of Richard Shor.)

Murray Handwerker

His father, Nathan, borrowed $300 from Jimmy Durante and Eddie Cantor to start his landmark Coney Island restaurant. Behind Nathan's counter sat Murray in a makeshift playpen made from a three-by-three-foot an empty hot dog roll crate. One could say he grew up in the business. After college and World War II service, he continued working at Nathan's but was looking to expand the family's business. Oceanside's Roadside Rest had been shuttered for years. He acquired the property and reopened it in 1957. A year later, his father bought it from him, and together, they created Nathan's Roadside Rest (opened June 4, 1959). The new restaurant became the second Nathan's in history. The food selections were amazing for a fast-food restaurant. Fried clams, lobster rolls, and frog legs were on the menu with traditional burgers and fries and, of course, the most delicious hot dogs in America. Nathan's was an experience. It had a game room where kids could play pinball and other coin operated games all day for just a few dollars. On its six-acre property was Kiddieland Park with a carousel and rides. Music and dancing at night eventually faded, giving way to puppet shows, birthday parties, motorcycle Tuesdays, and NFL Films Night. Many from Oceanside have fond late-night teenage memories of Nathan's. It was the place to go after a date and a hangout after the beach before going home. Murray Handwerker created a great part of the childhoods of many. According to his son Bill, he was a man of entrepreneurial acuity and integrity but, more importantly, a loving husband and father. (Courtesy of Bill Handwerker.)

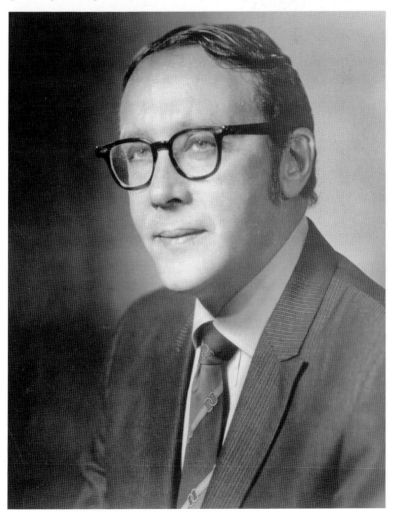

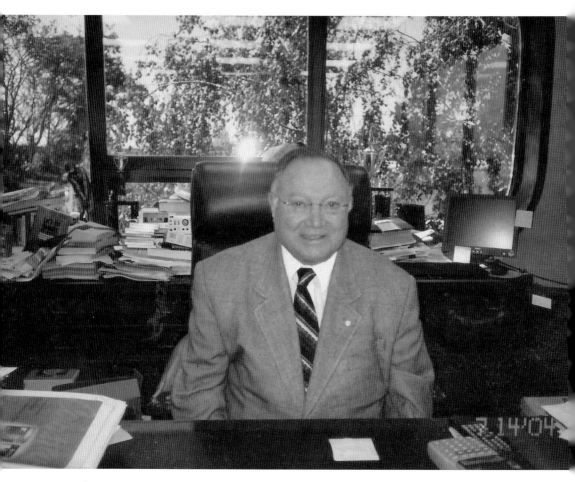

Roger Folz

Business people recognize Roger for creating the largest bulk vending company in the United States. The Oceanside community recognizes Roger's soft heart and philanthropy. Roger started his business in 1949. For over 50 years, his machines were placed in stores across the country. Each president since Eisenhower has been gifted with one. His kindness is legendary. He is a vital member of Rotary Club and has served as national vice president of the Muscular Dystrophy Association. He was a major donor to the Barry and Florence Friedberg JCC, and he gifts numerous scholarships to Oceanside High School graduates. When Folz Vending was sold, Roger shared his profits with his employees—a week's pay for every year with the company. Oceanside is honored to have Roger in the community. He serves as a model for business and generosity. (Courtesy of Roger Folz.)

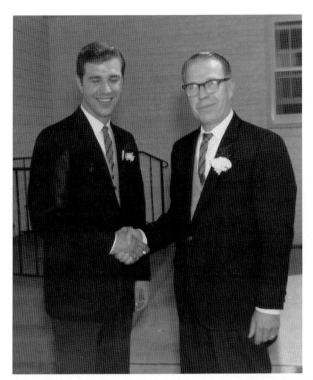

Earl Towers

Earl Towers is remembered as Oceanside's "adopted native son." He was from Canada but his lifeblood was the Oceanside community. In 1933, he bought Gilda Gray's house on the corner of Foxhurst and Long Beach Roads and converted it to a funeral parlor. Earl, pictured with son Bob, was a charter member of the Kiwanis Club, past president of the board of trade, a Lutheran church councilman, and a founding member of Rescue Company No. 1. (Courtesy of Robert Towers.)

Emil "Kip" Janowski

Kip's dad opened a small supermarket, T. Janowski & Sons, near Oceanside's Memorial Triangle in 1926. Kip later assumed the store, which became Janowski's Hamburgers. Kip was a member of Kiwanis Club and of Columbia Engine Company No. 1. His store, Janowski's Hamburgers, proudly sponsored Oceanside youth sports teams. A golfer of note, Kip won many amateur tournaments including the Breakers Seniors Golf Championship in Palm Beach three times. (Courtesy of Bill Vogelsberg.)

Pasetti's

Al and Serafina Pasetti's luncheonette was a landmark in Oceanside. A patron could sit at the counter and enjoy an ice cream soda or sit in a booth for a hot meal. Down the block from School No. 6, it was a favorite of teachers and students. Everybody was family at Pasetti's. It closed in 2003 after 50 years. The Pasettis' son Steve, pictured with his dad, Al, recently opened a deli, Pasetti's on the Woods. The legend continues. (Courtesy of Steve Pasetti.)

Johnny Russell's

Johnny Russell's, now Union Park Café, was a place during Prohibition to sneak a drink. Family-owned since 1933, it is still a true cozy neighborhood hangout. It is a place for dinner, an impromptu class reunion, and civic meetings, and at one a time, bowling was even available in the basement. The picture shows Scott (left) and John C. Russell flanking their father, John. John C. "Johnny" passed away in 2011. (Courtesy of Scott Russell.)

Farmer Joel's

Over the last 20 years, Michael Franzini and his sister Carol Riecker (pictured) made Farmer Joel's the "place to go" for produce, catering, or sandwiches. It is an old-fashioned family business maintained with Mike's wife, Joanie, and his sister Susan. Susan's son Steven is the master chef. Farmer Joel's generously donates to school events, sponsors local teams, and works to beautify the community. Michael and Carol were recognized as Business Persons of the Year in 1997. (Courtesy of Maria Heller.)

Fred Rigel

Levin's Drugs is one of the community's oldest businesses. It has been filling prescriptions since 1922. In the 1950s and the 1960s, it was a place for teens, serving ice cream and soda at a lunch counter. Fred Rigel is its current proprietor. Fred, pictured outside his store with Kathy Towers, is known as an honest, caring family man. He sponsors youth sports teams, the PAL, and school district activities. He was Business Person of the Year in 2000. (Courtesy of Maria Heller.)

Ciamillio's Music

In 1957, Martha and Anthony Ciamillo opened Oceanside Music, originally teaching both music and dance. Oceanside Music School is a three-generation, family-owned business. It was founded with the ideal that music is for everyone and students should receive professional yet affordable lessons. Operated by John Ciamillo, its president, and wife, Lori, who runs the music school, its tradition of making beautiful music with the Oceanside community continues. It was selected as Oceanside's Business of the Year in 2013. (Courtesy of Justine Woods.)

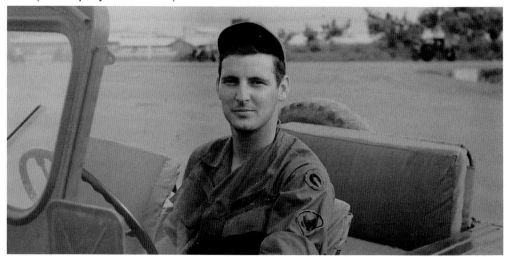

Joseph Bonin

After returning from Vietnam in 1970, Joseph wished only to be a restaurant/bar owner. Twelve years later, JPaul's opened. With its warm, cozy atmosphere, people gravitated to it. Joseph has an engaging personality and can talk basketball all day. He generously donates to charitable events and sponsors local teams. He was Businessman of the Year in 2011, an accolade he shares with his wife, Lorraine, and sons, Joseph and Bryan. (Courtesy of Joseph Bonin.)

Hank Bialick

The *Oceanside Beacon* covered local news, school district happenings, recreation activities, civic organizations, and youth league sports. It began in 1954. Hank Bialick, pictured with wife, Florence, took over as publisher in 1978. She was the paper's editor. He is a lifetime member of the John A. Kissell VFW and a member of Oceanside Jewish War Veterans Chwatsky-Farber Post. He was selected as Business Person of the Year in 1990. (Courtesy of Maria Heller.)

Joseph Quagliata

Oceansiders have watched South Nassau Communities Hospital grow in size and in services. Joseph Quagliata has facilitated its progress. For 40 years, he worked toward improvement. As chief financial officer and later CEO, he broadened services and expanded outpatient care. Facilities have been developed including a Dialysis Center and a Center for Cardiovascular Health. He serves on many boards to further improve health care here and in New York State. Joseph retired in 2013. (Courtesy of Gail Carlin, South Nassau Communities Hospital.)

INDEX